Nature's
Laguna Wilderness

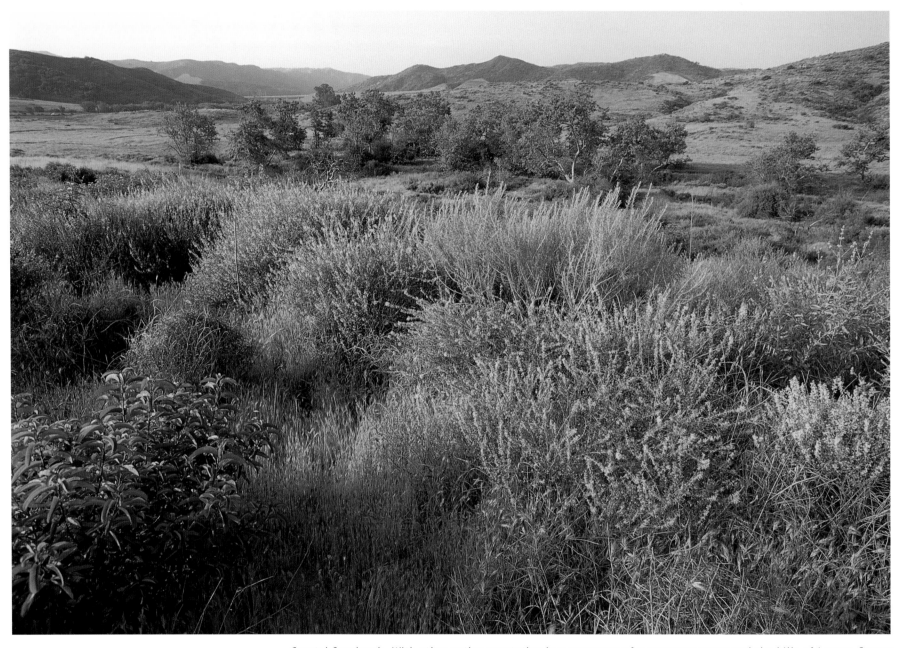

Coastal Sagebrush. With other native vegetation in a panorama of a sycamore grove and the hills of Laguna Canyon.

Nature's
Laguna Wilderness

by RONALD H. CHILCOTE

Laguna Wilderness Press
Laguna Beach, California

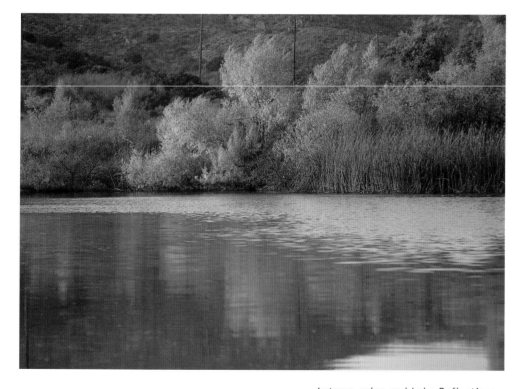

Autumn color and Lake Reflections

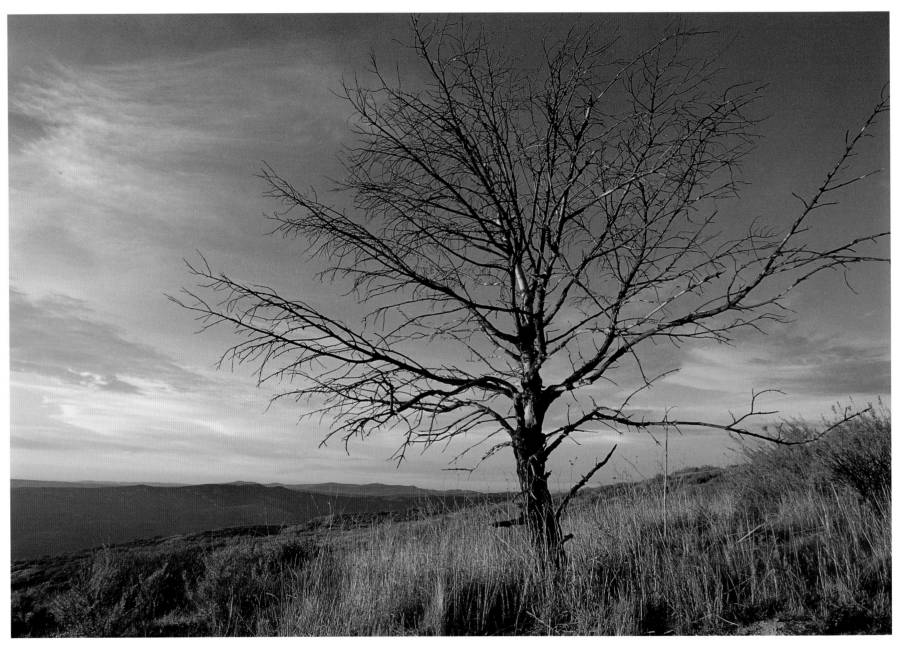

Lone Tree. Remnant of the l993 Laguna Fire.

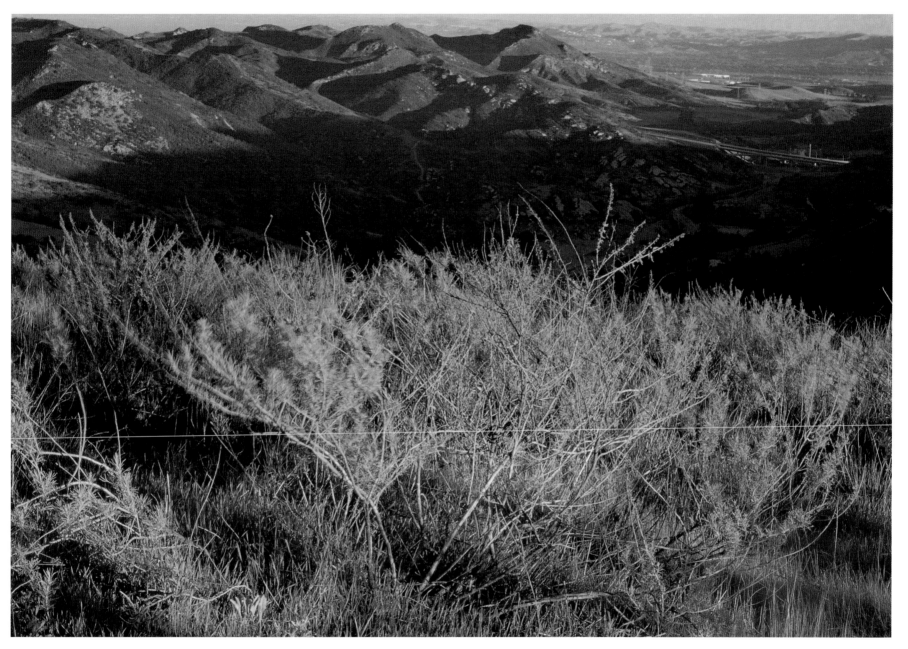

Above Little Sycamore Canyon

Nature's Laguna Wilderness

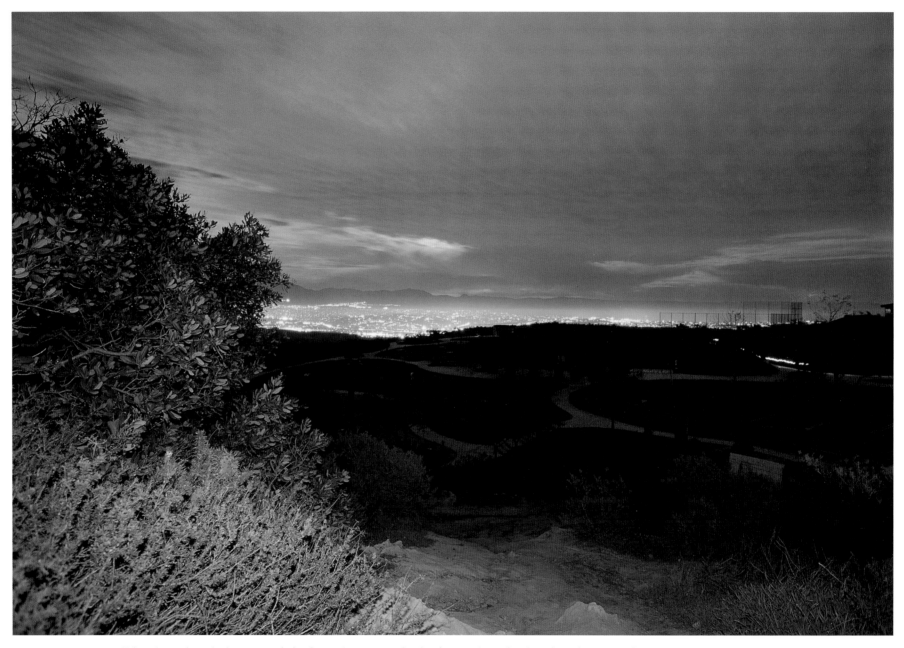

Urban Intrusion. A view toward the Santa Ana mountains in the evening, showing the urban areas between Wood Canyon and the mountains beyond.

Dedication

To Jim Dilley, who inspired all of us to appreci-
ate the richness of the Laguna Wilderness, and
to all who carry on with his vision.

Acknowledgments

I am deeply appreciative to many for their
input. To those who reviewed and commented
and whose suggestions were helpful: Elisabeth
Brown, Jerry Burchfield, Mark Chamberlain,
Fran Chilcote, Gene Felder, Mary Fegraus,
Anne Frank, Eric Jessen, Barbara Metzger,
Michael Pinto, and Carolyn Wood. Park rangers
Barbara Norton and Larry Sweet reviewed the
text and were helpful in orienting me to the
wilderness areas. Jerry Burchfield worked
closely in all phases of the project and was
especially helpful toward the end in laying out
an order for the photos. Barbara Metzger edit-
ed the manuscript. Eric Jessen and Scott
Thomas provided data for the maps. We
worked closely with David Caneso, Mark
Caneso, and Paul Paiement who designed the
book and maps. Greg Lee and Mark López of
Imago guided us through the scanning, produc-
tion, and printing process. Randy Jones and
George Thompson of the Center for American
Places were especially helpful in the final
phase of the project. We acknowledge the
generous support of the Laguna Canyon
Foundation, the Laguna Canyon Conservancy,
and the Laguna Greenbelt, Inc.

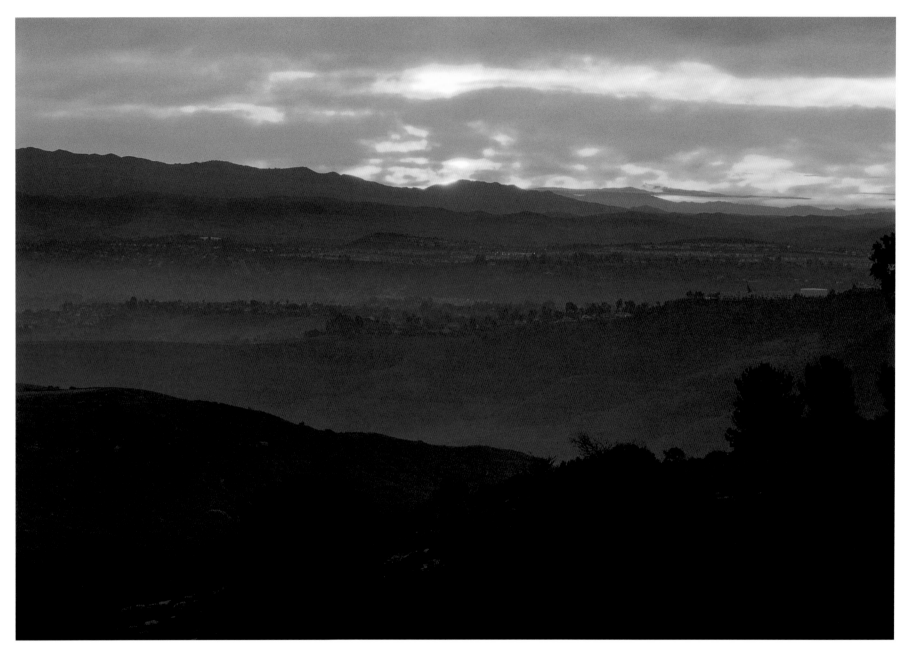

Sunrise over Wood Canyon. From Alta Laguna to the Santa Ana mountains.

Contents

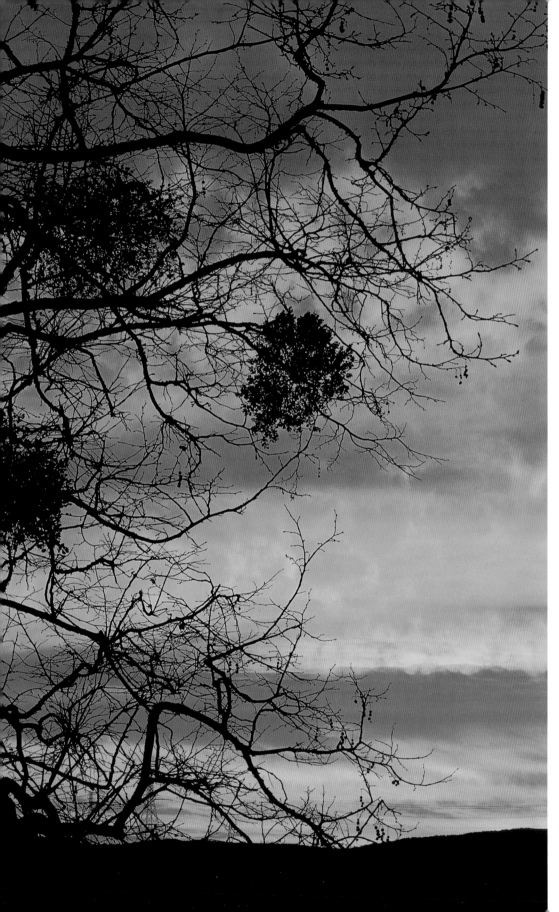

Dormant Sycamore and Mistletoe at Sunrise.
Below Little Sycamore Canyon.

Foreword

I still have childhood memories of riding in the backseat, while my Dad drove us down a dark, narrow, winding road lined with trees through Laguna Canyon to the ocean. For a child from suburbia, it was the equivalent of taking a trip through a primal forest, haunting yet fascinating.

Later, when I was old enough to drive myself, I would go through Laguna Canyon whenever possible. I loved breaking away from the urban congestion and freeways of Orange County onto the old two-lane stagecoach route, through the wilderness area to the City of Laguna Beach, known for its unique coastline, surf culture, hippie past and art festivals.

Enthralled with the community, I moved to Laguna Beach in 1971 and began making forays into the canyons, exploring and making photographs. Those of us who lived in Laguna Beach treasured the wilderness areas that separated Laguna from the rest of the world. Those commuting through the canyon to jobs inland described the drive home as their "cocktail." But as property values soared, development of the wilderness areas seemed inevitable. In response, several insightful individuals started grass roots organizations like the Laguna Greenbelt and Village Laguna with the hope of finding a means to preserve as much open space as possible and retain the village character of the city.

As a photographer, I have worked extensively in the Laguna Wilderness using the medium to focus attention on the need to save it from development. It was through photography that I had my first contact with Ron and Fran Chilcote. Within a short time, our mutual concerns and love for nature brought us together as colleagues working towards a common goal. Over the years, Ron and I have gone on countless excursions throughout the Laguna Wilderness, getting up before dawn and spending the day photographing its splendors.

Over the years the Laguna Wilderness has been the source of many paintings, photographs, poems and prose. It has also been the source of monumental battles between developers and those who recognize the value of open space and natural environments. However two things have been lacking. A comprehensive history of the area and a photographic study that would provide the public with a view of the natural wonders that exist beyond the fences lining Laguna Canyon Road.

The work for this book began with that need in mind during Chilcote's photographic explorations of the Laguna Wilderness in the early 1990's. In 1996, Chilcote formally initiated the project, seeking photographically to

capture the beauty and character of all segments of the Laguna Wilderness. Through the use of photography combined with the first comprehensive text on the history and geography of the area, Chilcote has created a volume that is an important contribution to regional history and universal efforts to preserve and enhance wilderness areas.

Working in the tradition of atmospheric landscape photography, Chilcote seldom embellishes his photographs. He responds to the moment, with deliberation and patience, seeking to capture the essence of his subject. As with most endeavors of value, he has labored over time, returning to the wilderness that he loves again and again, each time reaping new rewards.

The primary purpose of this book and the Laguna Wilderness Press is to increase public awareness of wilderness issues. Our goal is to convince the public that it is important to redefine our definition of progress. We believe that it is imperative that adequate wilderness areas be secured from development, not only on a regional level, but on a national and international level as well, since the problems faced locally are occurring everywhere.

The Laguna Wilderness Press is a non-profit press dedicated to publishing books concerning the presence, preservation and importance of wilderness environments. We plan to produce an on-going series of books that feature beautiful and thoughtful photographs in conjunction with perceptive and provocative text on specific environmental areas while addressing universal issues.

The Press was started due to our mutual concern for the preservation of the Laguna Wilderness. Recently, after years of struggle, the landowners, politicians and the people of Orange County have come together to mutually embrace the concept of open space being something other than a golf course. They have acknowledged the value of natural buffer zones within large urban environments. That is why, at this time, it makes me especially pleased and proud to present "Nature's Laguna Wilderness" as the first volume to be produced by the Laguna Wilderness Press.

Jerry Burchfield is a renowned photographer, curator, and author of books and art catalogues. He is a professor of photography and director of the photography gallery at Cypress College in California. His forthcoming book on the Amazon is entitled Primal Images.

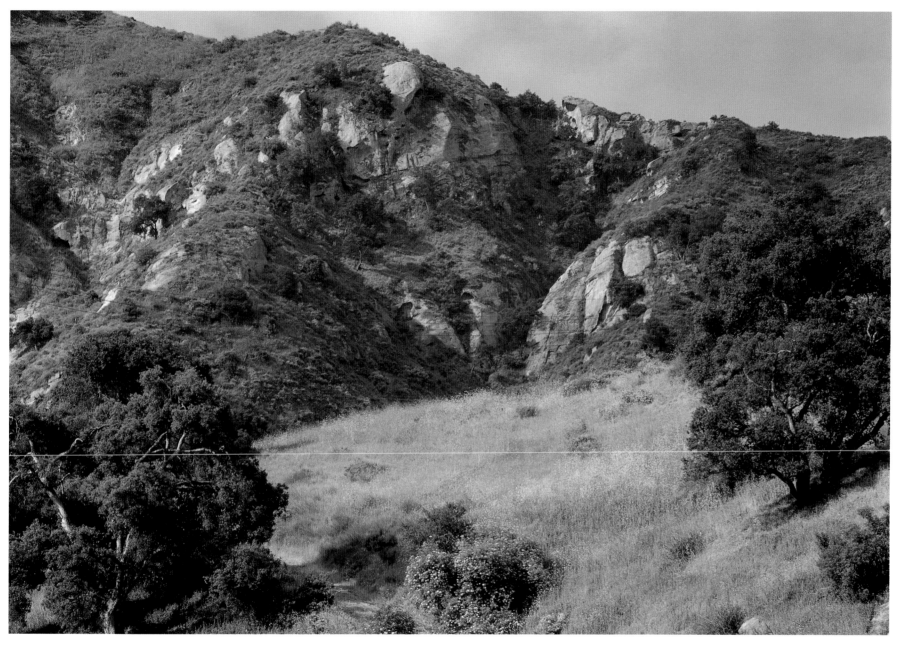

Oak, Sage, and Mustard in the canyons near Big Bend. A sense of how it has looked since the settlements of early peoples.

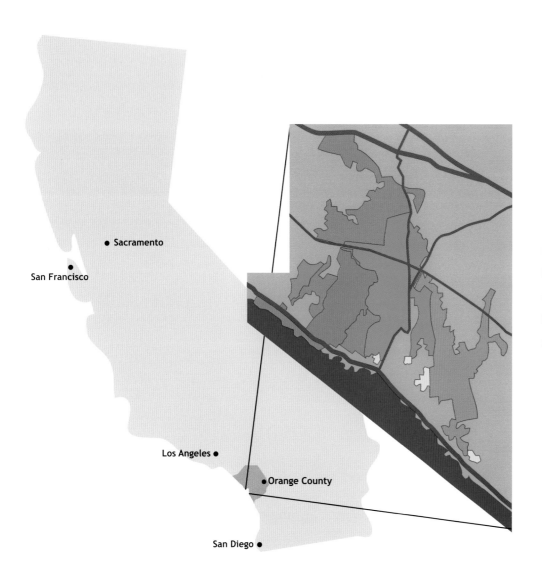

Sacramento

San Francisco

Los Angeles

Orange County

San Diego

Laguna Beach Open Space

Aliso and Wood Canyons Wilderness Park

Crystal Cove State Park

Irvine Company Open Space

Laguna Coast Wilderness Park

What motivates a photographer to commit himself to the struggle for the preservation of nature in the face of human intrusion and try to capture a beauty that endures to the present? I take my camera into the field to find peace and spiritual sustenance and to fulfill a commitment not only to preserving what is left of pristine nature but to pursuing the positive values of human existence. My convictions have largely been shaped by personal experience, but I also have been moved by the thoughts of others such as the late nature photographer Galen Rowell who believed that "behind every successful photograph of the past lies its power to endure" (2001: 26) and that photographers owe it to humanity to produce images of the truths they witness in the field; the writer Terry Tempest Williams who has reflected on how photography leads to conservation of wilderness areas and "a wash of images and emotion that returns us to our highest and deepest selves, where we remember what it means to be human, living in place with our neighbors" (2001: 3); and the Japanese painter Chiura Obata (1993) who shared with the photographer Ansel Adams a love of the Sierra Nevada and painted at different times of day and in varying weather conditions in search of a holistic vision of the mountains. I have also been influenced by Paul Rogat Loeb who writes we must heed our deepest convictions and act with others in shaping a better world while "connecting us with all that makes us human" (1999: 349) and by Seung Heun Lee who in a prayer of peace before the United Nations called on all of us to shun the paradigm of competition and domination and "to seek the spirituality of our beings" (2000: viii).

In April 1972 my wife Frances and I settled in Laguna Beach. Our participation in the community revolved around our immediate neighborhood and efforts to limit development so as to preserve open spaces within and around the city, and work through the local schools to improve education. We were founders of the Temple Hills Community Association, a civic group initially concerned with building community cooperation

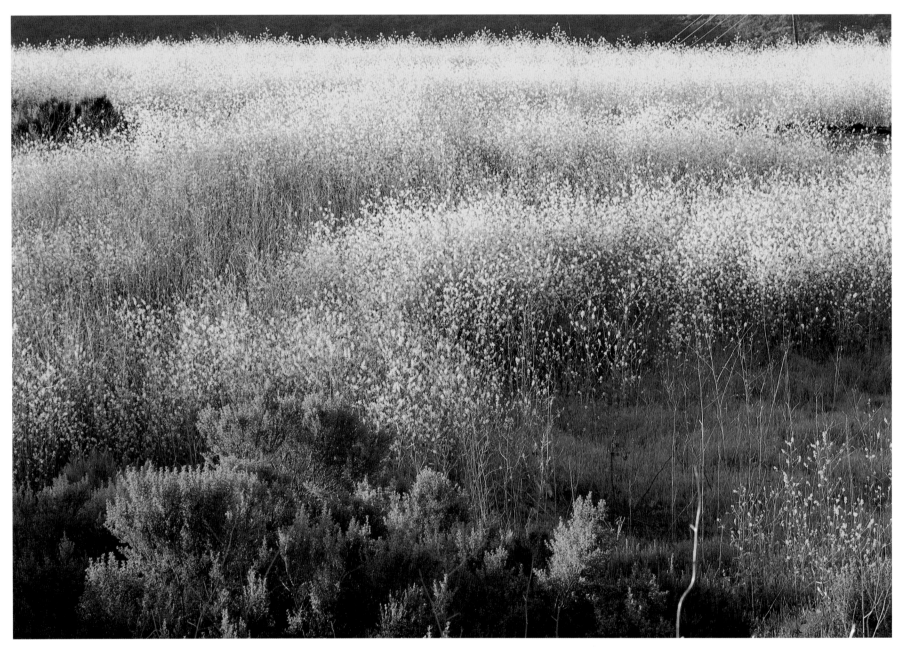

Coastal Sagebrush and Non-Native Mustard

and the preservation of the interior hillsides or inner greenbelt. Lagunans had become interested in planning for the future, prompted by an initiative to prevent high-rise buildings along the beach and to open the main beach to public access through a program of acquisition and creation of parks along the beach. Soon thereafter, I met Jim Dilley through a gathering he convoked under the auspices of the Citizens Town Planning Association, founded in 1967. In response to Dilley's call for neighborhood associations to formulate specific plans for their areas as a means of building civic pride, community spirit, and planning, Temple Hills embarked upon the development of a plan for the neighborhood, consisting of maps and a statement of principles and objectives, which included environmental concerns. Shaped by more than one hundred people, the plan was never formally adopted by the city, but the community implemented portions of it. Dilley also had produced a plan for downtown Laguna Beach which envisioned underground transit from the canyon to the beach and parking outside Laguna Beach with public transportation into town. The ideas were visionary and beyond

the immediate problems and concerns of city officials, but they provided impetus to citywide urban planning and eventually to a general plan and a specific downtown plan designed to retain the "village atmosphere." Another civic organization, Village Laguna, had coined this expression in the aftermath of protest against high rise and the recall of a city councilmember and resignation of the mayor.

Monkeyflower and Bush Lupine

At the same time another struggle emerged in the district school system, when a conservative school board dismissed a popular superintendent and attempted to dismantle two progressive schools that by the late sixties had achieved national reputations. A recall election failed by a handful of votes, but the movement behind it continued with endorsement of two candidates, including myself. Elected in 1974, I insisted that the movement supporting me carry on through a broadly based group calling itself Dialogue on Schools. A newsletter with the same name appeared monthly during my nine years on the board. Those involved in my initial campaign

included Barbara Metzger, who edited the monthly newsletter and later became a member of the city's design review board and its planning commission; Verna Rollinger, who was elected and served a quarter century as city clerk; and Sally Bellerue, who became a councilmember from 1976 to l984. All of us were involved in Village Laguna, and many of us in the Laguna Greenbelt to which I directed most of my attention.

I began attending strategy sessions of the Laguna Greenbelt in 1974 and 1975 with Jim Dilley, Tom Alexander, and Judge Paul Egly along with consultant Mike Schley. In 1975 I formally joined the Laguna Greenbelt board and served for many years as its vice president. I remain a

Web Mosaic. In wood canyon

board member today and think of myself as a link with the origins and early history of this effort now that all of the original members have left the board and all but two are gone. Part of my role is reminding members of our mission to conserve and consolidate in the face of nearly insurmountable obstacles, applying pressure from a strong environmental and ecologically sensitive

position and fighting to retain as much open space as possible. Recently I have also advocated the acquisition of the inner greenbelt within Laguna Beach, primarily the pristine hillsides threatened with development.

My photography project in the Laguna Wilderness commenced formally in December l996 and continues today with frequent field trips into the area surrounding Laguna Beach from Irvine and Newport Beach in the north to Aliso Creek in the south. The project evolved in several phases, the first phase, from December 1996 to May 1997, resulting in a preliminary portfolio of images organized into clusters around highlands, wetlands, and woodlands. One of them was photographed in the early morning of the Christmas full moon on December 25, 1996, a rare occurrence that happens once every hundred years. The second phase extended from the middle of 1997 through 1999 and involved extensive photography and exploration throughout all the canyons and highlands of the Laguna Wilderness with the effort aimed to document and capture interesting images from all parts of this wilderness. The third phase has moved in a

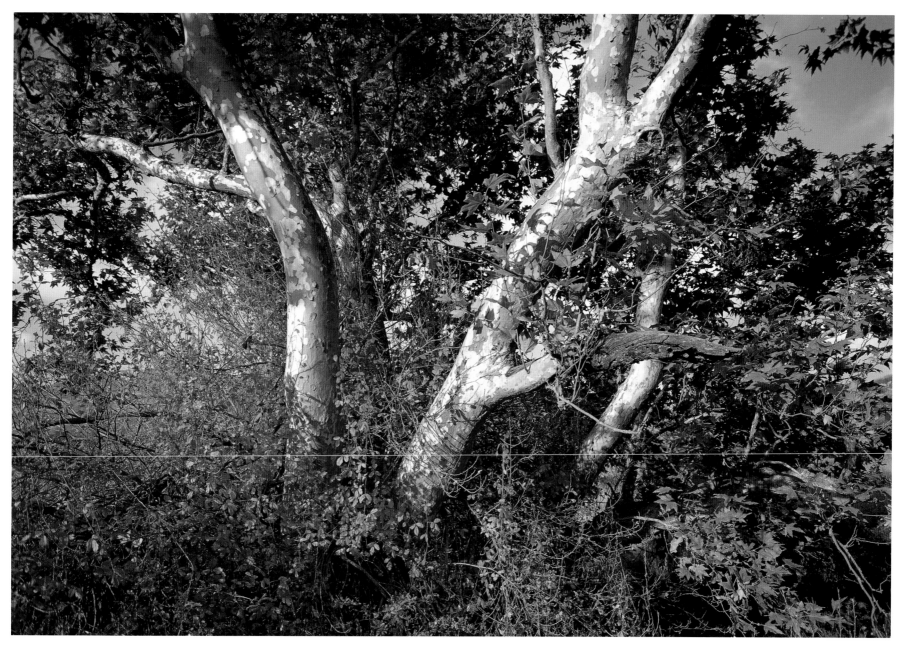

Red Glow of Poison Oak and Sycamore

Upper Little Sycamore Canyon
A view east toward the Santa
Ana and San Bernardino ranges

different direction, focused on the same geographical areas but incorporating some of the techniques I experimented with, physically manipulating the emulsion of Polaroid prints into impressionistic images reminiscent of the twentieth-century landscape painting in and around Laguna Beach that contributed to its reputation as an artist colony. This led to research on the plein-air painters of Southern California, especially in Laguna Beach at the turn of the twentieth century and ensuing decades. The early painters devoted attention to landscapes within and surrounding the city, and their images help to identify the natural setting, some later destroyed by development. The first prominent artist to arrive was Norman St. Clair in 1903. Among the early artists to buy property were George Gardner Symons and William Wendt in 1903 and 1906 and later Edgar Payne. Frank Cuprien devoted attention to the sea, while the Laguna landscapes of William A. Griffith and Joseph Kleitch were "accurate enough to be matched to historical photographs" (Moure, 1998: 191-192). Under the leadership of Anna

Hills and Edgar Payne the artists established a meeting place as early as 1913 and in August 1918 held their first exhibition, an event that would lead to the founding of the Laguna Beach Art Association, the Laguna Art Museum, and the Festival of Arts and its Pageant of the Masters (Turnbull, 1988). I was able to identify where many of the famous plein-air paintings were produced in town and in the surrounding wilderness areas. My survey initially was based on the paintings held by the Laguna Art Museum and represented in the museum's successful 1999 exhibit on colonies of American impressionism (Solon, 1999) so that they might be replicated through my cameras to show historical contrast and the impact of people and development on the area and its natural setting as a way of contrasting the present with the past. This project continues and hopefully will result in a companion volume to the present book. Additionally, I am encouraging a project to identify, photograph, and catalogue plein-air paintings of the past in and around Laguna Beach.

Ronald H. Chilcote
Laguna Beach, California

Introduction

The Laguna Wilderness is a unique and vast area of preserved natural landscape in the heart of urbanized Southern California. I focus on this pristine area with a desire to inspire hope and demonstrate the possibility of carving out natural landscapes for preservation wherever urbanization intrudes. Shaping of this wilderness emanates from a vision that became reality and exemplifies how people everywhere who care about their environment and nature can achieve control of precious space and hold it intact for future generations.

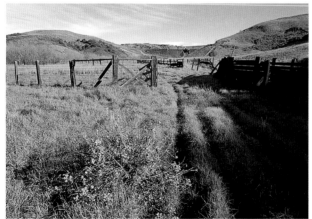

Old Moulton Ranch Fence in Wood Canyon

This wilderness is distinctive because of its proximity to the sea and desert. The cold currents of the Pacific sweep the coastal areas while the warm dry winds from the interior deserts occasionally flow toward the sea, producing a comfortable cool climate near the sea and a harsh warm climate inland resulting in a rich diversity of flora and fauna. This was once the home of early Native American cultures, and remnants of their life were once bountiful along the coast from Newport Beach to Laguna Beach. It also is the site of Orange County's only natural lakes, two fed by spring waters and the other a vernal lake. The lake district is a precious natural resource, but like some of the surrounding countryside, it has suffered from the intrusion of the early settlers and the later developers. During the rainy season several streams flow through distinctive side canyons that cut to the more prominent Laguna Canyon and along the coast to the ocean. Early painters often depicted a beautiful creek that once ran alongside this canyon, yet today only remnants of this stream are conspicuous during the rainy season, often flooding the downtown commercial area, but its existence has been gradually obscured by development. These intrusions into the natural

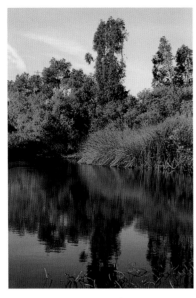

Autumn in Laguna Lake Two

setting have endangered the flora and fauna, one indigenous succulent being threatened by extinction, while the gnatcatcher has been placed on the list of endangered species.

This book is the product of more than a quarter century of activism in the struggle to secure and preserve what is popularly known as the Laguna Greenbelt—the undeveloped lands between the city of Laguna Beach and the developed interior of southern Orange County. What I call the Laguna Wilderness has many components, variously named Aliso and Wood Canyons Wilderness Park, Crystal Cove State Park, Laguna Coast Wilderness Park which includes the James Dilley Greenbelt Preserve, the Irvine Ranch Land Reserve, and the City of Laguna Beach Open Space. I desired to capture the natural setting and beauty associated with an area that is easily rec-ognized, but because it was fenced and inaccessible private land, today it is known only casually by some of us. Historically it was ranch land that extended into what has been developed into the cities of Irvine, Aliso Viejo, Laguna Niguel, and Laguna Woods and is contiguous to urban areas that now spread throughout South Orange County. This development and urbanization has had its negative impact, and dramatic changes are evident in photographs that document the area a generation ago and today.

It was with foresight and vision, however, that James Dilley, a local bookseller and resident of Laguna Beach, saw the need to preserve the area as open space, and in 1969 the small group that formed around his vision constituted itself as the Laguna Greenbelt. Those signing the initial September 26, 1970, bylaws of Laguna Greenbelt Inc. were Elinor Davis, James Dilley, Kay Dickerson, Carl Johnson, Robert Krantz, Catherine MacQuarrie, Les Remmers, Bea Whittlesey,

and John Wilkerson. Others active early on included landscape architect Fred Lang and cultural activist Barbara Stuart Rabinowitsh.

The ensuing text weaves through my images of this special area. Its objectives are twofold: first, to present a brief history of how people, from indigenous times to the present day, have impacted the wilderness. Historical accounts are incomplete and information contradictory, and my description attempts to weave a synthesis of what really occurred. Second, I depict the geography and geology of the area, along with reference to the flora and fauna. My emphasis is on images accompanied by brief captions, but the order of images and the accompanying text are broken into three segments: canyons and woodlands, wetlands, including lakes and streams and coastal waters, and flora and fauna.

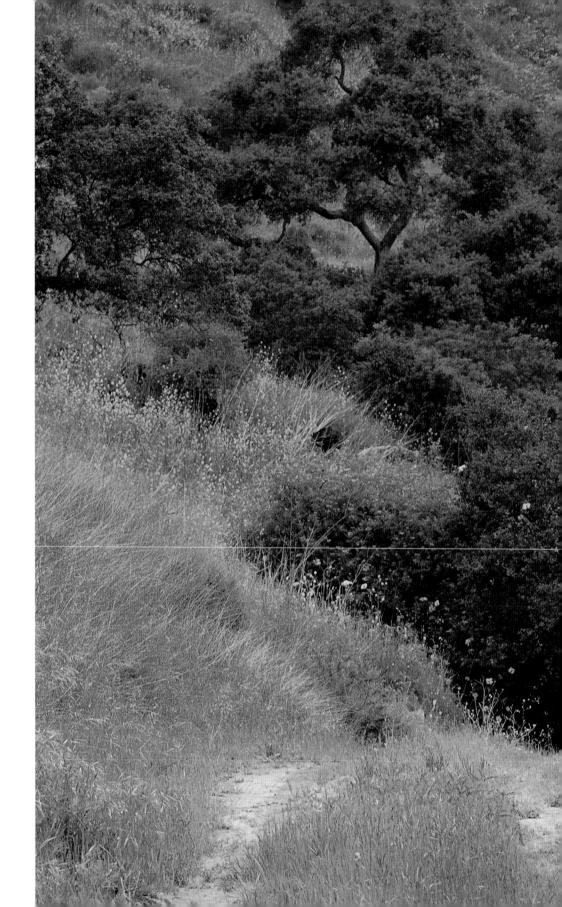

Pathway through Oaks.
With mustard and monkeyflowers in early spring.

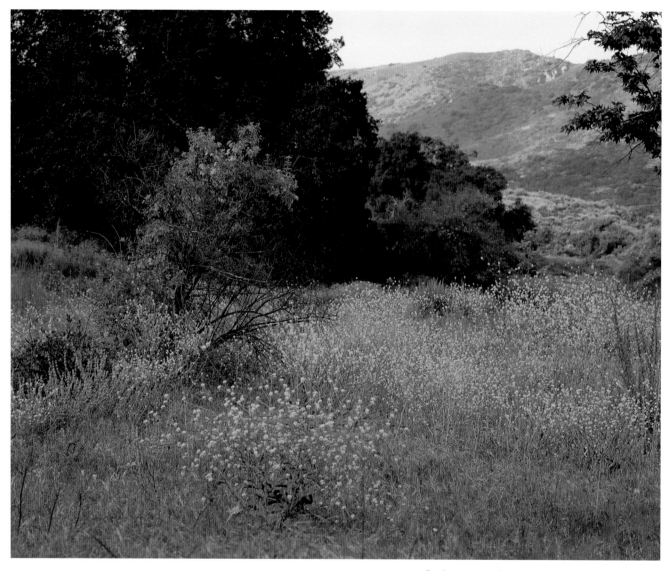

Spring Mustard and California Coast Live Oak

The Historical Legacy

Originally the Laguna Wilderness was home to Native Americans. Remnants of their cultures are scattered in and around Laguna Beach. The archeology of Orange County is meager. There are no great burial sites, but Morris-Smith (1979) has studied a burial ground in the caves of Sycamore Hills now named as the James Dilley Greenbelt Preserve. Two early Native American cultures are known, the first being the Ute-Aztekas and later the Shoshones, who occupied the canyon lakes known as the Lagonas, apparently a distortion of the Spanish La Cañada de las Lagunas. These names were retained until 1904 when the area became known as Laguna Beach (Luna-Seeden, 1985: 3-4). Most references to Native Americans today in the area are identified with the Acachemem Indians and the Juaneño Band of Mission Indians in the San Juan Capistrano area (see photos and references in Estes and Slayton, eds, 1990: 41-44 and 141-144, and accounts drawn from the priests John O'Sullivan and Gerónimo Boscana in Meadows, 1966). Native Americans undoubtedly lived in caves, but generally they resided in villages of a few dozen to several hundred persons in houses of brush or tules lashed to a frame of poles. Signs of Indian occupation are common as evidenced by soil flecked with charcoal on every ridge that ends at the sea between Corona del Mar and Dana Point. Some sites are believed to have been occupied for thousands of years, although water was scarce, seed-bearing plants were abundant during the summer and fall, and along the coast the rocky shores and bays were full of sea life. Acorns from the oak trees provided another source of nourishment. Their language of Shoshonian origin differed within small areas, for example the Indians south of Aliso Creek had difficulty communicating with those north of the creek (Meadows, 1966: 28). In 1769, the Franciscan priest, Juan Crespi, traveling with Spanish governor Gaspar de Portolá and his soldiers, appeared in Aliso Canyon and described it as: "All the valleys and hills on both sides are of pure earth, well-covered with grass, and without a single stone. So we went on over very open

country, with hills and broad mesas, ascending and descending through three or four little valleys of good soil well-grown with alders" (Meadows, 1966: 41). He described the Indians as passive and friendly. They soon would become dependent on the Franciscan mission established November 1, 1776, as San Juan Capistrano, the first permanent Spanish settlement in Orange County.

In the nineteenth century much of the Laguna Wilderness became part of Spanish grants (up to 1822) or Mexican land grants (from 1822 until 1848). To the north of Laguna Beach the 48,803-acre Rancho San Joaquín (later the Irvine Ranch) was carved out by two grants (April 13, 1837, and May 13, 1842) to José Sepúlveda. The first, known as "Swamp of the Frogs" extended from above Newport Bay to Red Hill in Tustin, and the second, called La Bolsa de San Joaquín included what then was Laguna Canyon Creek. To the south the 13,316-acre Rancho Niguel (later the Moulton Ranch) was granted to Juan Ávila and his

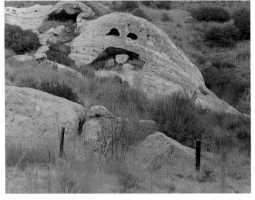

Face in Rock.
A familiar image at the entrance to Laurel Canyon.

sister Concepción (June 21, 1842) on land on both sides of Aliso Creek between Laguna Canyon and the mission lands of San Juan Capistrano. José Serrano, who in 1842 was granted lands where present-day Laguna Hills is located and established the Rancho Cañada de los Alisos, had been grazing his cattle in Aliso Canyon since 1836 (Meadows, 1966: 100-102). The land between the San Joaquín and Niguel ranches was settled by Mexicans José Antonio María Acuña and Ysidoro Olivares before California was relinquished by Mexico in 1848. Olivares homesteaded 50 acres in what today is Laguna Woods and worked at the nearby Rawson Ranch. On his death at the age of 107 in 1933 the land was inherited by the Daguerre family, apparently descendents of Louis Jacques-Mandé Daguerre, the French inventor of the daguerreotype, the first practical photographic process (Ramsey, 1976: 4-5). At one time Jean-Pierre Daguerre owned a third interest in the Moulton Ranch (Viebeck, 1995:8).

From the 1850s on, cattle roamed the area now known as Laguna Beach, although the drought of 1862-1864 brought devastation: "For years dry bones lay around the dried up water

holes where the cattle had come to drink and where they had died by the thousands piling on top of each other. For years the dry bones were ground up for fertilizer" (Ramsey, 1976: 100).

James Irvine, an Irishman who had come to San Francisco in the mid-nineteenth century and made his fortune as a merchant in the California Gold Rush, purchased the Rancho San Joaquín from José Sepúlveda in 1864 and the Rancho Lomas de Santiago from William Wolfskill in 1865. In 1876 he formed the Irvine Ranch. With his death in 1886, the ranch passed to his son, James Irvine II, who assumed control in 1893 at the age of twenty-five. He moved his family from San Francisco after the earthquake in 1906 (Irvine Ranch, [2001]), and decided to shift the land use from ranching to agriculture. This resulted in the replacement of cattle and sheep by oranges and vegetables. The ranch became the world's largest producer of lima beans, and in 1967 its 971,820 orange trees produced a million boxes of oranges (36).

With the changing landscape and conditions only

Rock Wall of Upper Little Sycamore Canyon

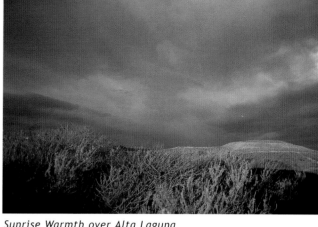

Sunrise Warmth over Alta Laguna

remnants of the old ranch exist today. For example, the Bommer Canyon cattle camp remained the site of cattle operations on the ranch to the 1970s ([2002]: 24), and it was the site of a dedication of 2100 acres of open space by The Irvine Company to the City of Irvine on May 18, 2002. The original ranch home, built in 1876, was destroyed by fire in 1965, and at this writing there are plans to rebuild and restore it to its original form.

During World War II 4700 acres of the ranch were sold to the U.S Navy for construction military facilities, including the air base at El Toro. Its closure led to several elections over what to do with the property, with Newport Beach and many North Orange County cities favoring an international airport and a majority of South Orange County cities desiring a large central park and preservation of wildlife lands and corridors connecting to the Laguna Wilderness. The dispute was finally settled in March 2002 by a popular vote in favor of a large park and preservation.

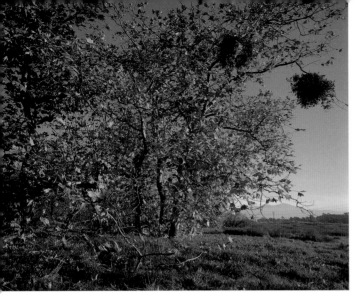

*Little Sycamore Grove.
A view of Saddleback
Mountain at the entrance to
the canyon.*

With the death of James Irvine II, in 1947, The Irvine Ranch fell under the control of the Irvine Foundation. Twenty years later it was sold to outside investors, and in 1983 Donald Bren became the majority stockholder. In 1965, the Irvine campus of the University of California opened, and in 1971 the City of Irvine was formally established and carefully planned as a community. These and ensuing decisions enormously changed the character of the land and the landscape.

The rapid growth of Orange County and its emergence from World War II was accompanied by conservative movements "steeped in national-ism, moralism and piety" (McGirr, 2001: 8) and national recognition as a stronghold for conserva-tive Republican politics (Olin, 1991A and 1991B). Even some conservatives, however, objected to the unbridled development that was sweeping the county. Tom Rogers of San Juan Capistrano, for instance, who had served as finance chairman of the ultraconservative John Birch Society and as chair of the Orange County Republican Central Committee, became a leader of a slow-growth movement in the county. In her history of this politics, Lisa McGirr has shown how the spiraling growth of the county provoked wealthy ranchers and homeowners to defend the open spaces and beauty that shaped the places where they lived. They fought corporations like The Irvine Company, Rancho Mission Viejo, and Mission Viejo Company, which sought to reduce open space. A rancher, Rogers became involved in a struggle with developers who sought to pave over a creek and develop land close to where he lived. He labeled corporate developers "the whores of the twentieth century," and he associated "with unlikely bedfellows, such as progressive environ-mentalist Larry Agran" (McGirr, 2001: 268). He joined Agran in the effort to stop the interna-tional airport and build the great park at El Toro.

After California became independent and despite the early droughts and other obstacles, Laguna Beach attracted many settlers. The first, Eugene Salter, homesteaded 152 acres in Aliso Canyon, and in 1871 his abandoned cabin was

occupied by George Thurston and his family. They remained fifty years on what was later known as the golf course at Ben Brown's restaurant and Aliso Canyon Lodge located along Aliso Creek just before it reaches the beach and sea (Ramsey, 1976: 44). William and Nathanial Brooks settled in 1876 at Arch Beach. In 1878 John Damron homesteaded the flat land above Arch Beach and part of Temple Hills. Henry Rogers homesteaded an area from Temple Hills to Bluebird Canyon. Two years later Frank Goff settled on land north of Aliso Canyon, and a few years later Harvey L. Hemenway homesteaded 500 acres in Laguna Canyon (Jones, 1997: 356-361). Later the Damron property (presently downtown Laguna Beach) was sold to George Rogers whose home stood on the site of city hall in front of the enormous pepper tree he planted (Viebeck, 1995: 7). Adjacent to his home, Rogers founded the first school. In 1888 a new school was built by Mormans in Laguna Canyon near the intersection of El Toro Road and Laguna Canyon Road, and in 1893 it was moved to Canyon Acres and later to Legion Street (Turnbull, 1988:124).

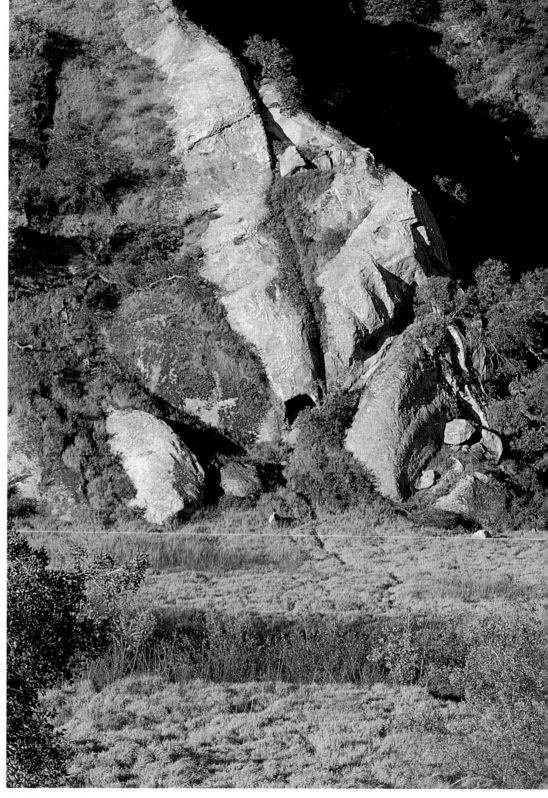

Rock Outcroppings at Laurel Canyon

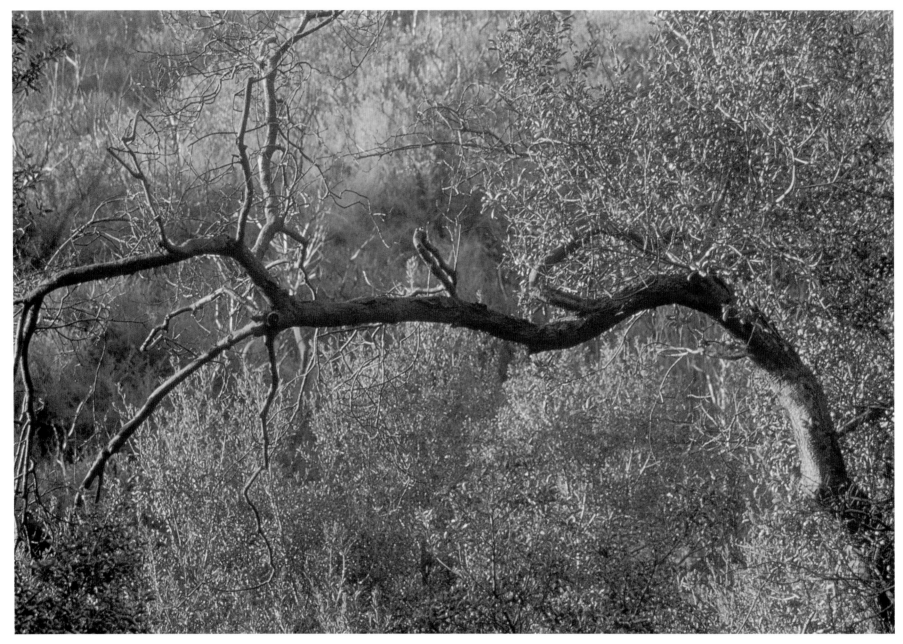

California Sycamore in Laurel Canyon

The site later became the home and studio of renowned photographer William Mortenson.

Laguna Canyon provided the trail initially used by Native Americans, and later it was occupied by settlers and thieves. It was to become the southeast line of the San Joaquín Grant and the Irvine Ranch. William Brooks facilitated travel through the canyon with the first stage line for a handful of residents and visitors, having successfully sued the Irvine Ranch which in 1886 had closed off the old trail that ran through Laguna Canyon (Blacketer, 2001). Water was available there for the cattle of the Irvine and Moulton Ranches (Ramsey, 1976: 44). In 1907 Frank Richey, a beekeeper, drilled a well for his home in Laguna Canyon, and until 1945 visitors to Laguna frequently stopped there for water. In 1914 the Skidmore brothers built a water line from the canyon and supplied water to homes in Laguna Beach until 1926 when the brackish water persuaded voters to abandon the wells in favor of a new water district (Ramsey, 1976: 50). (About 1975 I worked with Jim Dilley in writing a short position paper that advocated opening up these water sources, since he believed that the public had been deceived by special interests).

With the droughts of 1919 to 1921 the old dirt road through the canyon was improved, and due to the lake partially drying up, a bridge was placed so that it would not have to be forded in the wet season. Eventually the bridge was replaced by a culvert which filled with silt, creating two lakes (Blacketer, 2001). The droughts resulted in people using Laguna Creek, which flowed during the rainy season, as their dumping ground, and dirt was shoveled in so it could be forded: "In the name of development, owners straightened the once meandering stream bed so that it was out of their way. Eventually there was no channel to be seen at the Big Bend" (Blacketer, 2001: 8). Laguna Canyon also suffered from flooding which also led to decisions to pave over and channel the creek. In the early 1990s the culvert between the lakes on Laguna Canyon Road was replaced at a lower level, resulting in flooding during the raining season.

Tragedies have had an impact on both the natural environment and the people who live nearby. On October 27, 1993, a fire swept through the Laguna Wilderness and across the

road to the communities of Canyon Acres, Mystic Hills, and Temple Hills, resulting in evacuation of the city and the destruction of nearly four hundred homes. Two years later, downtown Laguna Beach suffered from multiple rains and flooding caused by the controversial San Joaquín toll-road construction. On December 7, 1997, seven inches of rain fell in twelve hours, and with more rain in February 1998 the canyon hills turned to mud and slid off the rock outcroppings and covered a portion of the road below to a height of eight feet, with the destruction of 15 homes and the death of 2 people.

With Jim Dilley's death in 1980, Tom Alexander emerged as president of the Laguna Greenbelt. With the inspiration and financial support of a local banker, Larry Ulvestad, Alexander pushed the idea of establishing an Orange Coast National Park that would consolidate the coastal area from Laguna Beach to Corona del Mar. This project involved expansion of the Laguna Greenbelt activities, the hiring of a full-time consultant, Michael Scott, and lobbying in Congress for a bill to establish the park. All the pieces of legislation were in place when Ronald Reagan was elected president in 1980, and his opposition to park legislation in general caused the Laguna project to collapse. Fortunately, the state stepped in at this point and acquired the beach area today known as Crystal Cove State Park. The negotiations were the culmination of a law suit filed by the Friends of the Irvine Coast, under the leadership of Corona del Mar realtor, Fern Pirkle. The purchase was tied to preservation of the Crystal Cove cottage community, established early in the twentieth century, and concessions to The Irvine Company to develop 2200 acres along the north coast. The ensuing plan included restoration and conversion for public use of the privately owned cottages and replacement of a trailer park at nearby El Moro with camping facilities. [As of this writing these plans were about to be implemented despite objections from the private owners, and the north-coast development was well underway, involving such impacts as pollution in the runoff through Muddy Creek.] For the Laguna Greenbelt, this was an era of consciousness raising, substantial fundraising, and an increase in membership through the publication of a reputable newsletter.

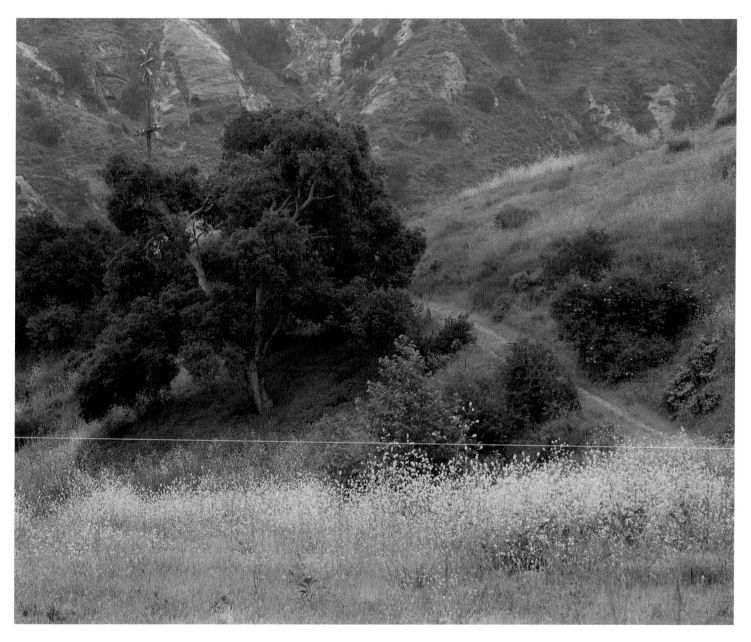

Coast Live Oak and Spring Mustard

Alexander was succeeded as president, briefly by Jon Brand and Terry Timmons, and then by Elisabeth Brown, and under her long tenure to the present the Laguna Greenbelt continued the struggle to constrain intrusion into the greenbelt wilderness and to enhance and preserve the protected areas. Developers, however, were generally able to obtain the concessions they needed for rapid growth in the nearby Aliso Viejo area and penetration into the greenbelt periphery of Aliso, Wood, and Mathis Canyons.

The struggle to save Sycamore Hills had ended with its purchase by Laguna Beach in 1978, preventing construction of two thousand homes. The Irvine Company, however, had secured approval for the construction of 3200 homes on 2150 acres in Laguna Canyon. The Irvine development posed a major threat, and despite public opposition the project appeared inevitable.

In 1980 photographers Jerry Burchfield and Mark Chamberlain, who saw the canyon as the last remaining natural corridor to the Pacific Ocean in Orange County and one of the largest open spaces in Southern California, initiated the periodical documentation of the threat to its survival. They set out systematically to photograph every inch of the nine miles from the Santa Ana Freeway to the ocean at ten-year intervals during day and night (1980, 1990, and 2000). Their aim was "to bring the area into sharper focus as a microcosm of a larger universe and, hopefully, elevate the discussion regarding the definitions and connotations of 'progress' in today's world" (Chamberlain, 1988: 17).

In 1989, as part of their Laguna Canyon Project, Burchfield and Chamberlain conceived and coordinated the mounting in Sycamore Hills of a 636 foot-long public mural named The Tell made up of one hundred thousand photographs contributed by the community and held a public rally against the future development. The Great Walk to the mural was a catalyst to save the canyon and drew eight thousand people to protest the proposed development of the canyon. This soon resulted in an agreement between Laguna Beach and The Irvine Company for the city's acquisition of five canyon parcels. A city referendum approved by almost eighty percent

of Laguna voters raised $20 million toward the purchase price of $78 million. The Laguna Canyon Conservancy under the leadership of Carolyn Wood was decisive in mobilizing the walk, and the fundraising efforts of the Laguna Canyon Foundation, founded in 1990 under executive director Mary Fegraus and president Michael Pinto, kept interest in the continuing effort for land acquisition alive.

Public opposition was insufficient, however, to overcome the determination of Orange County and private developers to construct a toll road, the San Joaquín Hills Transportation Corridor, through the heart of the greenbelt. Behind-the-scenes efforts by Elisabeth Brown and the Laguna Greenbelt board helped produce an alternative plan, shaped by the architect Lawrence Halpirn, that would mitigate the visual impact of the original design and open up corridors for wildlife. During the latter half of the nineties, as parts of the wilderness were formally incorporated into parklands, the Laguna Greenbelt effort shifted to preserving and enhancing the area, including restoration of the lakes, planting of native vegetation, and alignment of the canyon road. A docent program was established to provide guided

Sycamore in Upper Laurel Canyon.

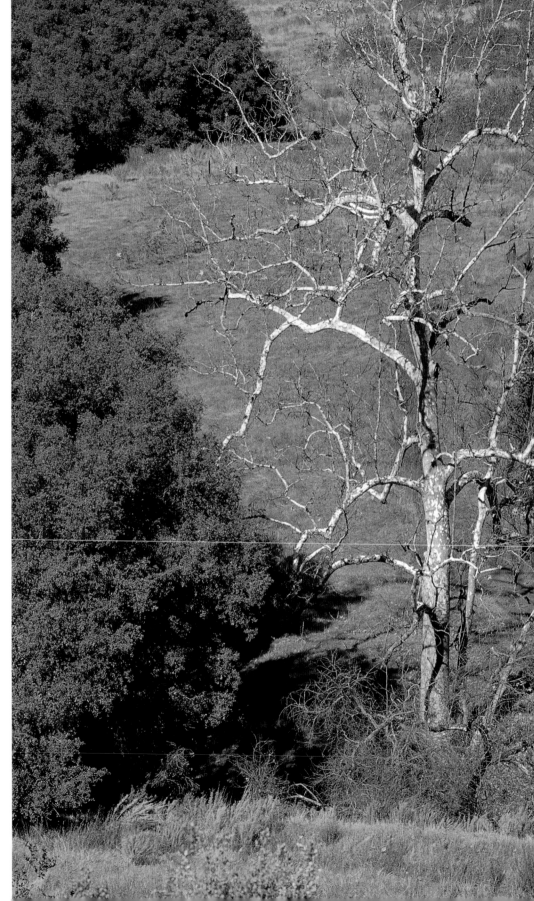

tours of the wilderness, some of them jointly sponsored by the Laguna Greenbelt and the Laguna Canyon Foundation and others by The Nature Conservancy that administered reserves of land turned over by The Irvine Company.

The Irvine Company has reminded the public of its dedications dating to 1897 when it gifted land to Orange County that became Irvine Regional Park. In November 2001 it gifted a 173-acre parcel in Laguna Canyon that the City of Laguna Beach had agreed to purchase but had been unable to fund. This completed the acquisitions desired by the thousands of Lagunans who had walked to Sycamore Hills to preserve the canyon a decade earlier.

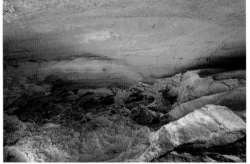

Dripping Rock.
A robber's cave in Wood Canyon.

The wilderness had grown to 17,000 acres plus a couple thousand acres of marine preserves. Only an area to the east and south of the Laguna Canyon from the boundary with the City of Irvine to the 405 freeway remained to be added to this wilderness area, and it was expected this land too would soon be secured.

The dedication in May 2002 of 2126 acres as part of the Open Space Agreement with the City of Irvine in 1988 was offset by The Irvine Company plans to build 2500 homes on 591 acres in Bommer Canyon. This had stirred up controversy in January 2002 when the Juaneño Band of Mission Indians objected that Indian artifacts would be destroyed. Two caves of drawings and carvings believed by anthropologists to date back 1700 years were at the center of the controversy (*Los Angeles Times*, January 3, 2002, Section B:1, 10).

Related geographically to the east and south of the Laguna Wilderness was the last big wilderness area in Orange County comprising 23,000 acres of undeveloped land owned by Rancho Mission Viejo with Richard O'Neill and family. Thousands of homes were proposed for this precious unprotected open space, and environmentalists were mobilizing to oppose the proposed development.

The consequence of all these efforts is a swath of rugged parkland of twenty thousand acres stretching in a crescent from the former Aliso Pier north to Newport Coast Drive. This greenbelt open space includes the Laguna Coast Wilderness Park, Aliso and Wood Canyons Wilderness Park, and Crystal Cove State Park.

Essential Moments

in the Formation of the Laguna Wilderness

1969 James Dilley establishes the Laguna Greenbelt organization which a year later becomes a non-profit corporation, the Laguna Greenbelt Inc.

1970 Christmas rock and peace concert of twenty thousand persons in Sycamore Hills, possibly the first time Laguna Canyon open to a large public gathering.

1972 Dilley persuades the Orange County Board of Supervisors to include the concept of the Laguna Greenbelt which in 1973 is given priority in the Open Space Element of the Orange County General Plan.

1975 California Coastal Commission recognizes the greenbelt concept.

1976 An initial acquisition involves a 20-acre parcel on the South Laguna ridgeline, just south of Three Arch Bay and now known as Emerald Ridge.

The second acquisition comprises a 20-acre parcel atop Niguel Peak on the South Laguna ridgeline and on the south wall of Aliso Canyon.

Friends of Irvine Coast forms to negotiate and monitor open space as trade-off for development in Newport and Corona del Mar. (In 2002 the name changed to Friends of Newport Coast).

1978 Purchase of Sycamore Hills by the City of Laguna Beach from Great Lakes Carbon Corporation. City of Laguna Beach receives County funds in exchange for the ultimate right-of-way for the toll road, the San Joaquín Hills Corridor.

1979 Negotiations with Aliso Viejo Company result in dedications of Aliso Wood, and Mathis Canyons. Orange County purchases 80 acres from Hobert McCaslin in the Top of the World area.

Orange County purchases Badlands from Daryl Spense. Other negotiated dedications from AVCO, Laguna Sur, Monarch Summit, and Shappel Industries.

1980 Laguna Greenbelt effort (since 1978) fails to establish the Orange County National Park through the U.S. Congress.

State of California with $32 million purchases from The Irvine Company 2888 acres of beach and back-country land, including Moro Canyon, between Laguna Beach and Newport Beach.

1984 Crystal Cove State Park formally dedicated.

1986 Preservation of Moulton Meadows between Top of the World and Arch Beach Heights.

Laguna Canyon Conservancy established.

1988 Irvine Open Space Initiative approved with open space dedication in Irvine portions of the Laguna Wilderness triggered by development approvals in related planning areas.

1989 Construction begins in January with dedication on August 19 of The Tell, a 636-foot photographic mural in Sycamore Hills. On November 11 eight thousand protesters walk to The Tell to oppose the proposed Laguna Laurel development.

1989 to 1990 Negotiations with the Irvine Company for purchase of Laguna Laurel. A lawsuit by Laguna Greenbelt against The Irvine Company and Orange County was the key to resolution in October 1990. Shortly thereafter The Irvine Company agrees to negotiate sale of the property for $78 million.

In November nearly eighty percent of Laguna Beach voters favor a $20 million bond issue for purchase of Laguna Canyon lands.

Orange County negotiations with The Irvine Company for 3600 acres above Crystal Cove State Park, including Los Trancos and Buck Gully. Formal dedications occurred from 1991 through 1999.

1991 Laguna Canyon Foundation founded. Irvine Coast dedications secure land on the north side of the Canyon Road.

1993 With the dedication of the Laguna Coast Wilderness Park, a Laguna Greenbelt volunteer docent training program is established to guide the public into the wilderness areas.

San Joaquín Hills Toll Road constructed despite opposition and lawsuits by Laguna Greenbelt and Laguna Canyon Conservancy.

1998 Laguna Greenbelt petitions for an Open Space Initiative within Laguna Beach to secure existing publicly owned open space lands adopted by the City Council in July.

1999 Two thousand acres of The Irvine Company Open Space Reserve transferred to Laguna Coast Wilderness Park.

2000 $12.5 million available for Laguna Wilderness open space via California State Proposition 12.

November gift of the final Laguna Laurel parcel by The Irvine Company for public open space.

2002 Dedication of 2100 acres, including the Bommer Cattle Camp as open space.

The Canyons & Woodlands

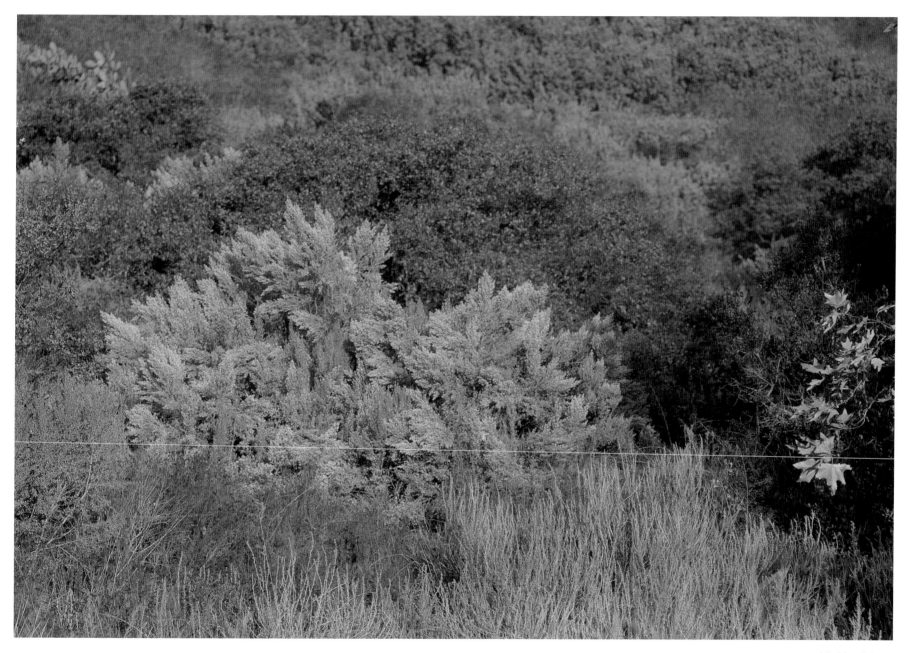

Highland Sage

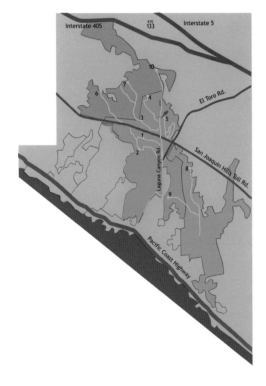

Aliso and Wood Canyons Wilderness Park

Irvine Company Open Space

Laguna Coast Wilderness Park

1. Laurel Canyon
2. Laurel Canyon & Willow Canyon Loop
3. Camarillo Canyon
4. Little Sycamore Canyon
5. Sycamore Hills
6. Bommer Canyon
7. Shady Canyon
8. Wood Canyon
9. Mathis Canyon
10. Laguna Canyon

Through the heart of the Laguna Wilderness runs Laguna Canyon Road, historically the access to Laguna Beach and now a twisting two and three lane road through the canyon from the freeways nine miles to the the ocean. Those of us who have traveled through Laguna Canyon appreciated its beauty and recognized how fortunate we are that our efforts have kept out most development that has consumed greater Orange County. Yet the canyon area is experiencing rapid change with construction underway to reroute the road to skirt the Laguna Lakes and rejoin the two lakes bisected by the present road. The realignment provides numerous wildlife undercrossings and gets the road out of the wetlands. The diversion to the northwest will require cut-and-fill in the hills alongside the new road, but the real problem will be the expansion of the road to four lanes. Many of us, of course, would prefer keeping the road as it always has been and restricting rather

than opening up traffic from the interior into Laguna Beach, but these changes are in the name of both "progress" and "safety" to reduce occasional accidents, the result of the hurry-up and tension-packed times we live in.

Off Laguna Canyon we encounter its side canyons and tributaries. Perhaps the most pristine and precious of all the wilderness canyons, Laurel Canyon nestles in a hollow shielding itself from the adjacent San Joaquín Hills Transportation Corridor toll road which abrasively cuts through the ridge above and to the east, imposing a barrier to the free flow of wildlife and opening it up to the sounds of traffic. During the early years of park organization the entrance to Willow Canyon off the Laguna Canyon Road has served as a staging area for scheduled walks. The canyon can be observed from Bommer Ridge above stretching from the staging area below to the access above to the coastal canyons to the west. From Bommer Ridge, there is also a way to Willow Canyon, about half the length of Laurel Canyon, dropping below to the Laguna Canyon Road and leading to trails to the Big Bend,

Laurel Bowl, and the water tank road. As one works through Laurel Canyon from below, the entrance exposes a dead walnut orchard below, unusual rock formations and outcroppings. Beautiful rock formations jut out on both sides. Toward the east a magnificent oak's trunks and branches appear dormant within the crevasse of the rock. An oak springs from the rocks above, its roots hanging down the rock and clinging to a long lasting life. Walking around and up the hill one looks back at the beautiful rock formations to the west

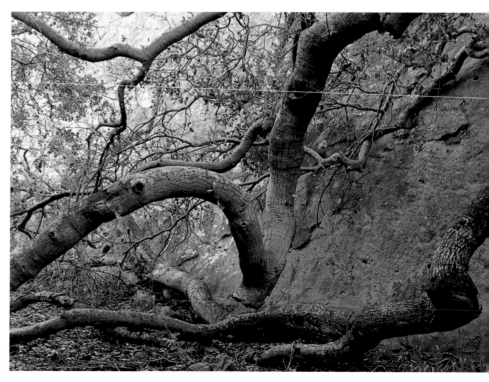

Split Rock and Old Sycamore.

dotted with caves and cracks. Certainly the plein-air impressionistic painters of the past created their landscapes here as they do today.

Further up Laurel Canyon, the groves are beautiful at all times, especially in the autumn as the sycamore leaves turn golden and red and in the early spring when the dry brown grasses yield to the renewal of verdant growth and flowers. Further up the canyon the waterfall is conspicuous during the rainy season. Tranquil dormant nature suddenly transforms itself dramatically into a gushing renewal of plant life, with bird life springing forth and other fauna, especially deer, coyote, and bobcat along with an occasional mountain lion reminding us that mankind's presence has not totally marginalized this precious refuge.

Camarillo Canyon runs contiguous and parallel to the east of the toll road construction which destroyed hundreds of sycamore and oak trees. Yet the hollow of Camarillo has been preserved, and although it is easily accessible

from the Canyon Road below, it necessitates some cross-country tracking at the outset into the groves above, few have traveled its course to Serrano Ridge above and the gateway to Bommer and Shady Canyons. Beautiful California oaks and sycamores line the trail cut in at least one major crossing by a water course that fills during the winter rains. The neighboring toll road clearly obscures this beautiful stretch of trail, yet what remains justifies familiarity and an occasional hike. As in Laurel Canyon, caverns may be found along the way, preserving the Native American legacy of the past and telling us not to disturb precious traditions, practices, and artifacts of those who once inhabited the area.

Little Sycamore Canyon runs further to the east and across from Sycamore Hills to the south of the Canyon Road. It flows from above into the Laguna lakes, and its entrance is marked by a beautiful grove of sycamores alongside Little Sycamore Creek. For me it is one of the most interesting groves in all the wilderness area, and I have photographed it frequently, but its natural setting is now disturbed by picnic tables and a staging area with

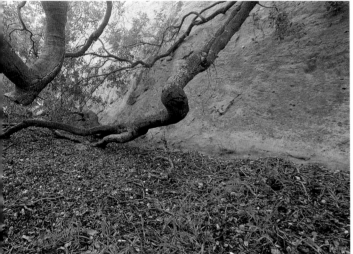

Split Rock and Old Sycamore.
At the base of Laurel Canyon across the creek
and not far from the abandoned walnut grove.

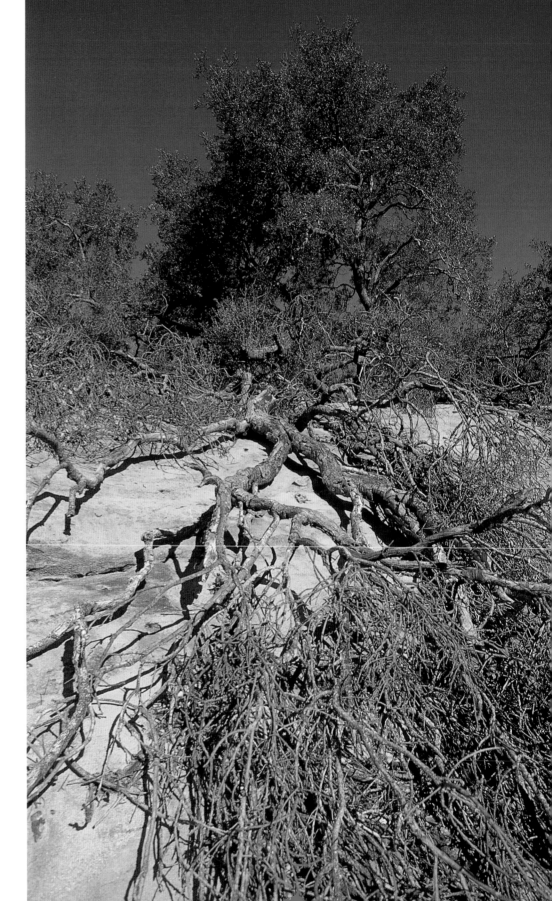

Big Rock and Oak.
at the mouth of Laurel Canyon.

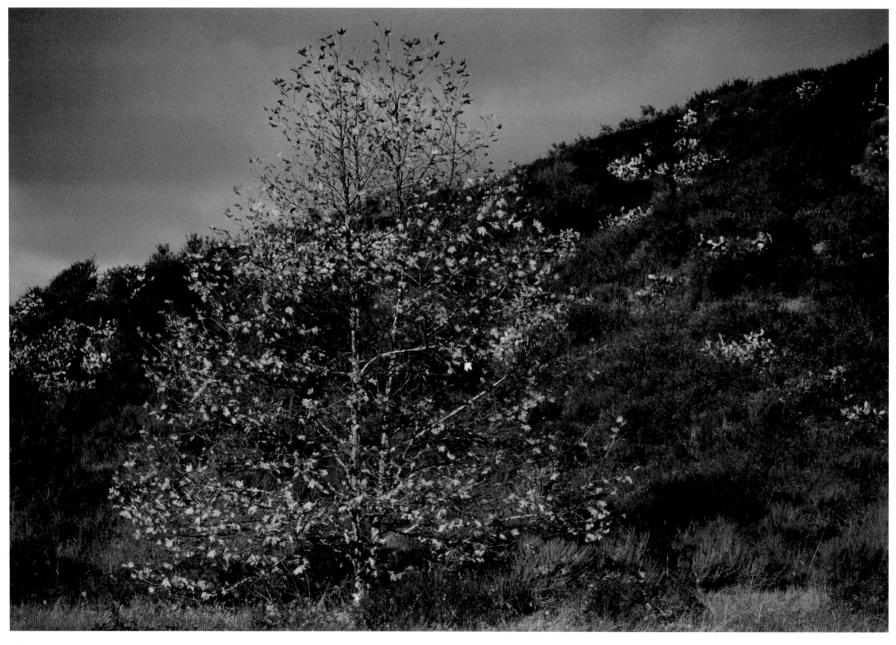

Sycamore in Autumn

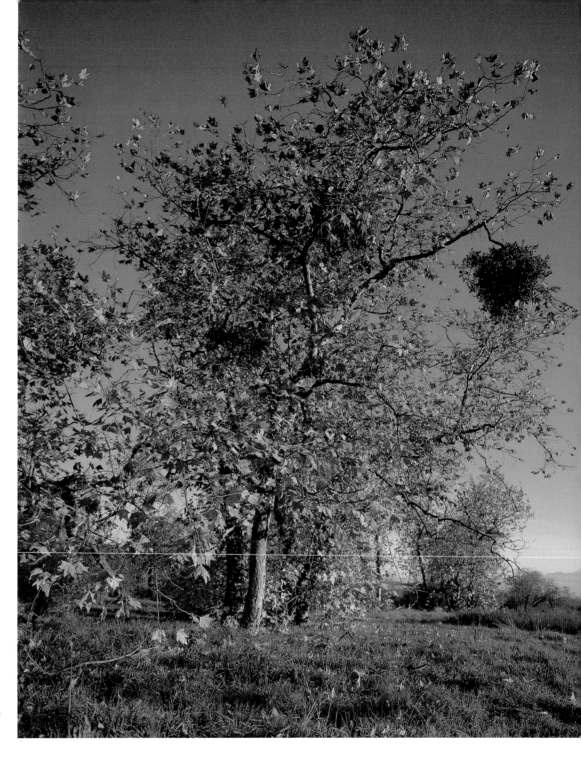

Soft Fall Light on Sycamores.
In early December the leaves drop, making
conspicuous the mistletoe in the tree branches.

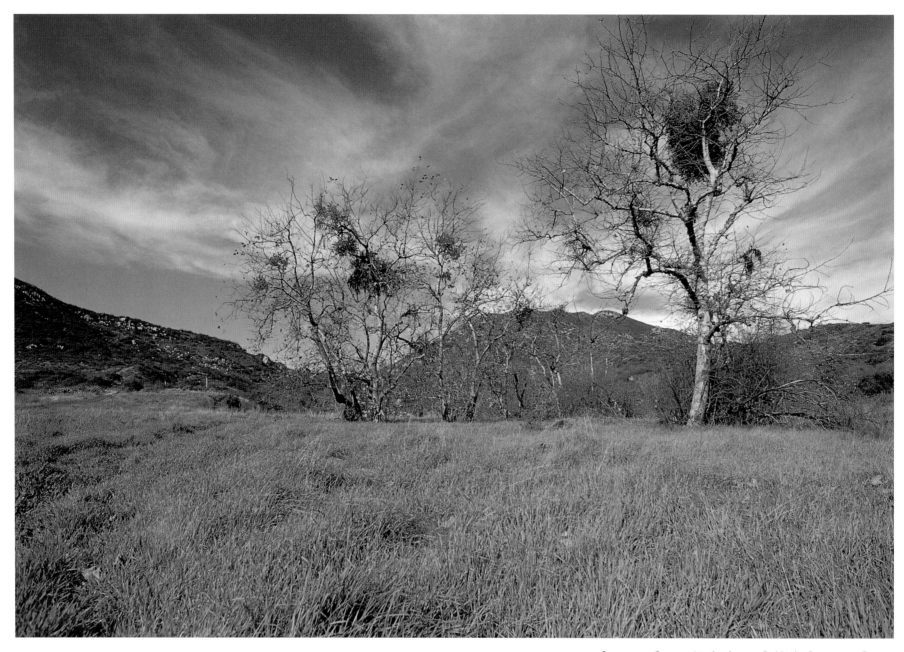

Sycamore Grove. At the base of Little Sycamore Canyon

the planned development of the park nature center, a rerouting of the Canyon Road, and the restoration and reclamation of the lakes below. It is a difficult area to photograph because of the harsh conditions throughout much of the year and background vistas exposing the urbanization beyond. Yet it can be exceptional for photography in both autumn and spring with the changing colors and dropping of the large sycamore leaves, the bunching of parasitic mistletoe clusters within the branches and the adjacent creek bed. My photographs of this entrance to the canyon below attempt to depict what remains on the side of nature. As one travels upward into the beautiful canyon, to the east the sharply rising rock walls of the canyon dramatically impose their natural barriers, dotted with caves of the former Native American inhabitants. The precipitous canyon walls are difficult to photograph as they are hidden from the warm rays of sunrise and partially shielded by the sunset light of the afternoon; in between the camera image usually is flat in the sunlight above. Yet nothing in the wilderness compares to this imposing canyon. Guided tours seldom reach the imposing walls of this very special and mystical place.

Sycamore Hills is an alluring place to photograph. The majestic old oaks and sycamores form magnificent groves. The new trees we planted not so many years ago are growing. During the late fall their leaves turn and glow in the backlight of the sunset and sunrise. Near the entrance the beautiful large trees stand in sharp contrast with the nearby intrusive toll road. The path up the canyon leads to the sycamore and oak groves. The walk to the ridge reveals the groves below in beautiful backlighting of the green, yellow, and reddish leaves and the soft lighting of the brown and parched grasses.

Sycamore Hills once was threatened with the development of thousands of homes, but public concern and eventual Laguna Beach intervention led to its outright purchase, an early effort to secure a portion of the wilderness from outside capital and disruption. Although the off and on ramps of the San Joaquín toll road now run alongside and

bisect the hills, they are somewhat contiguous to the old El Toro Road that skirts from the Canyon Road to the southeast toward Aliso Viejo and Lake Forest.

The preservation of the Sycamore Hills was important for many reasons. First, it has been a center for mobilization and raising of public awareness of impending development such as the once approved construction of The Irvine Company's Laguna Laurel housing project. In 1989 the massive wall of photographs named The Tell symbolized resistance to these threats, and the walk and gathering of eight thousand persons constituted a mobilization of public opposition that brought The Irvine Company to negotiations and to the city's eventual purchase of the approved Laurel project land. What is preserved today is the entrance and staging area for gatherings and hikes into the hills and contiguous fresh water lakes. The trails lead to ridges above and beautiful vistas below the sycamore and oak groves, and they take us into one of the most enchanting valleys of tree groves marked by very old growth that from above yields views with dramatic backlighting and contrasting colors, especially in the spring with the new verdant outburst of leaves on the sycamores and in the autumn with the yellow and red colors of the dropping leaves. Walking through this valley, often diffused by fog and the rising mist of early morning, one is overwhelmed by the enchanting and tranquil beauty of the place. As one enters the groves, the patterns of twisted tree limbs cast against the background of blue sky or clouds above yield magnificent images. At the end of the canyon nestled in the hills are caves that once housed Native Americans and their artifacts and perhaps their burial grounds. During my initial visit in the presence of Native Americans, I learned of their legends about this place, and I observed their respect and offerings to these sacred places. I saw their presence accompanied, first by four ravens and then four red-tailed hawks who flew over and circled us to remind us that we were intruders and to demand our respect for a sacred place. This awesome display was but a warning, but it tells us to acknowledge tradition and to let us know to keep our distance.

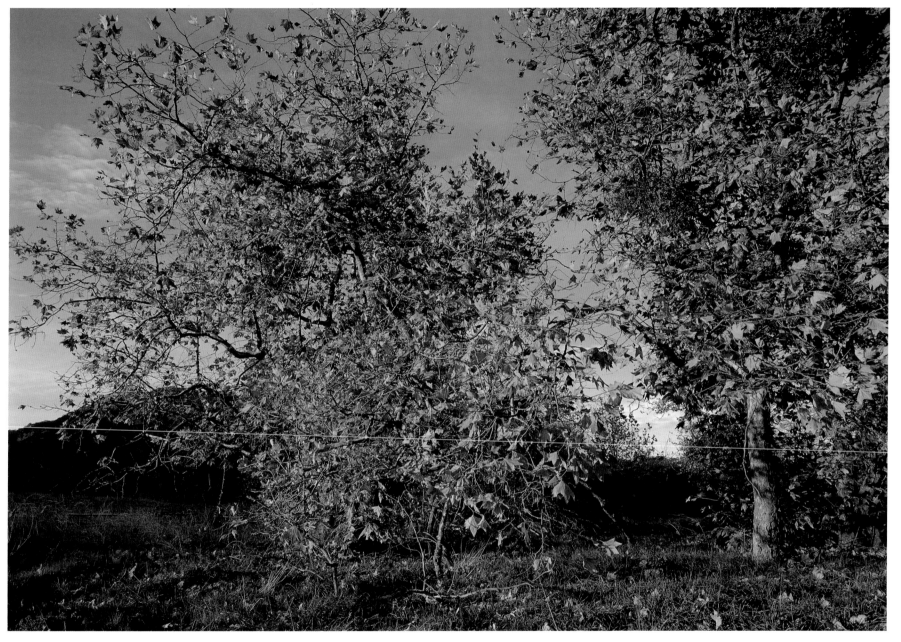

Little Sycamore Canyon Grove

Somewhat difficult to reach and not a tributary to Laguna Canyon but easily accessible from housing developments in Irvine proper, we find Shady Canyon to the northeast and Bommer Canyon to the west extend below Serrano Ridge and to the northwest of Little Sycamore Canyon. They are but remnants of the ranch lands, cut by dirt roads that once allowed control of the roaming cattle that grazed in these canyons. Ranching brought the introduction of intrusive non-native grasses and plants and left largely barren open spaces once covered by oak trees. Yet, some beautiful oaks and sycamores remain below the caves and rock outcroppings where I always stop to photograph.

Inland and to the south of but also not a tributary to Laguna Canyon, below Alta Laguna in Laguna Beach, stretch the beautiful Wood, Matthis, and Aliso Canyons. Several walking and bicycle trails reach down into these canyons. Walking east along the West Ridge one reaches a water tank and then the trail drops below into Wood Canyon to encounter dense oak and sycamore groves interspersed by Aliso Creek. A dirt road runs parallel to the creek, but footpaths branch away from it and provide contrasting vistas and photographic opportunities. From Alta Laguna it is also possible to hike down the steep hillside into Mathis Canyon and its tributaries of oak and sycamore trees and enchanting caves. Dripping Spring Cave, once a hideout for robbers, is perhaps the most exciting, especially as the early morning light reflects off its resplendent walls of fern and leafy growth, sometimes wrapped in dew. Mathis Canyon extends into Aliso Canyon toward Aliso Beach below, an area blocked off by the water company and the Aliso Creek resort. This was an area through which the early visitors and later homesteaders traveled, and it was a site for plein-air painting early in the twentieth century. Despite the water company's asphalt road that cuts down its middle, most of the canyon remains relatively untouched. All these canyons, of course have access from the Aliso Viejo development, and it was with shock in 1998 and 1999 that we observed how development was able to creep up and over the hills and intrude upon a natural setting that appeared to be lost to greedy developers. The rapid buildout of homes and inadequate planning resulted in pollution of Aliso Creek and its outflow to the beach to the west.

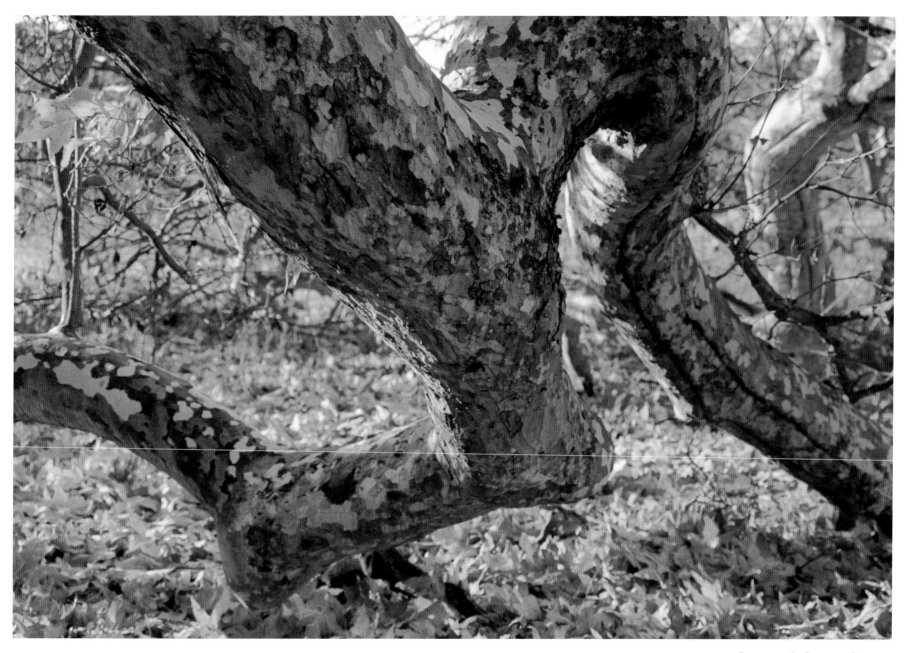

Sycamore in Bommer Canyon

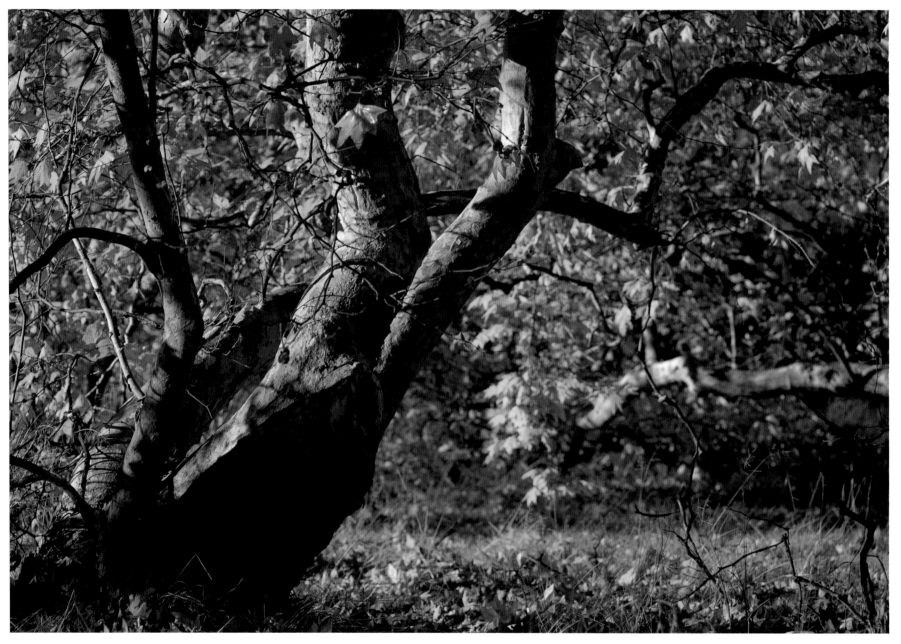

Sycamore and Fall Foliage in Bommer Canyon

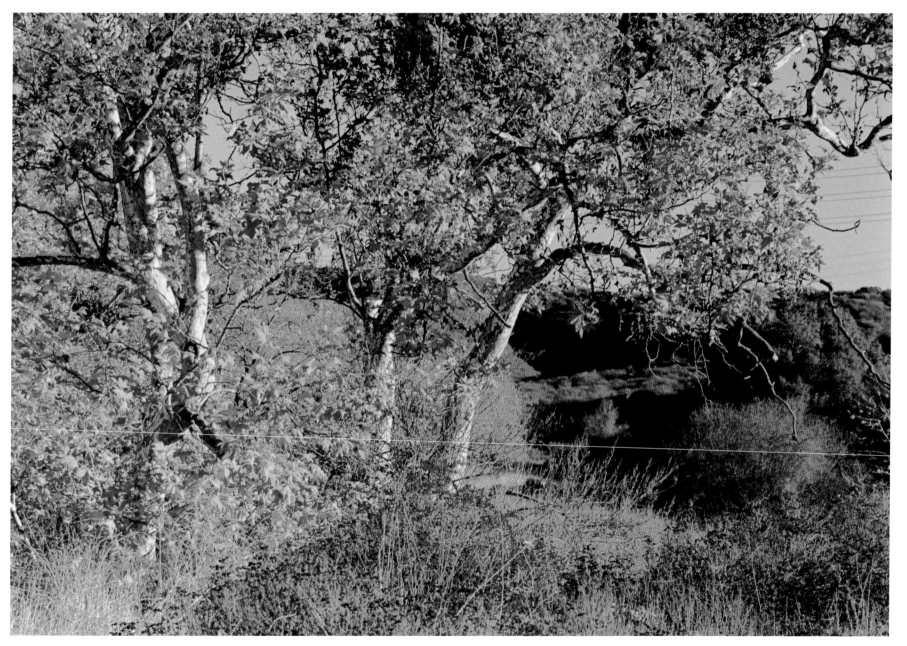

Sycamore and Hillsides along Bommer Canyon

Nature's Laguna Wilderness

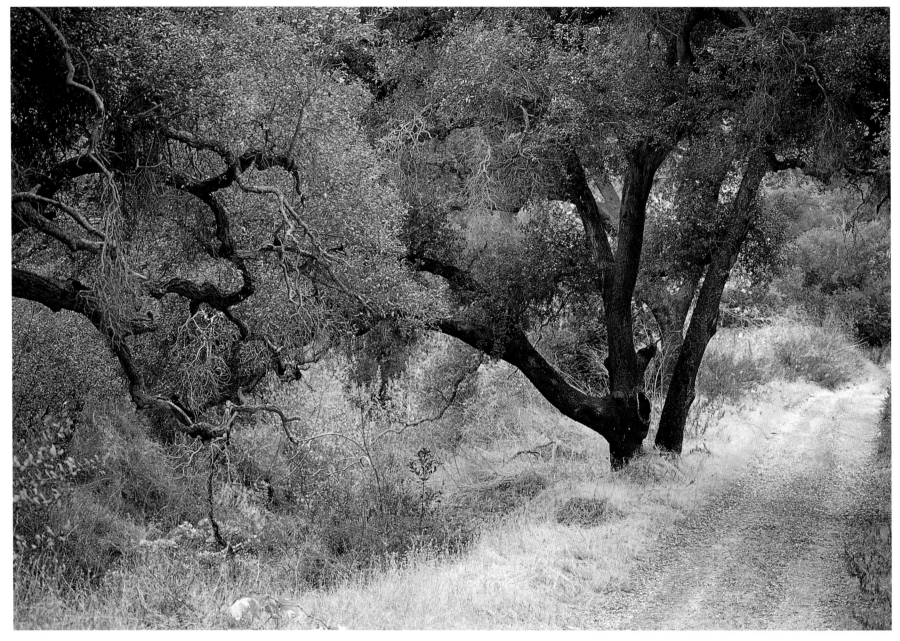

Emerald Canyon Pathway

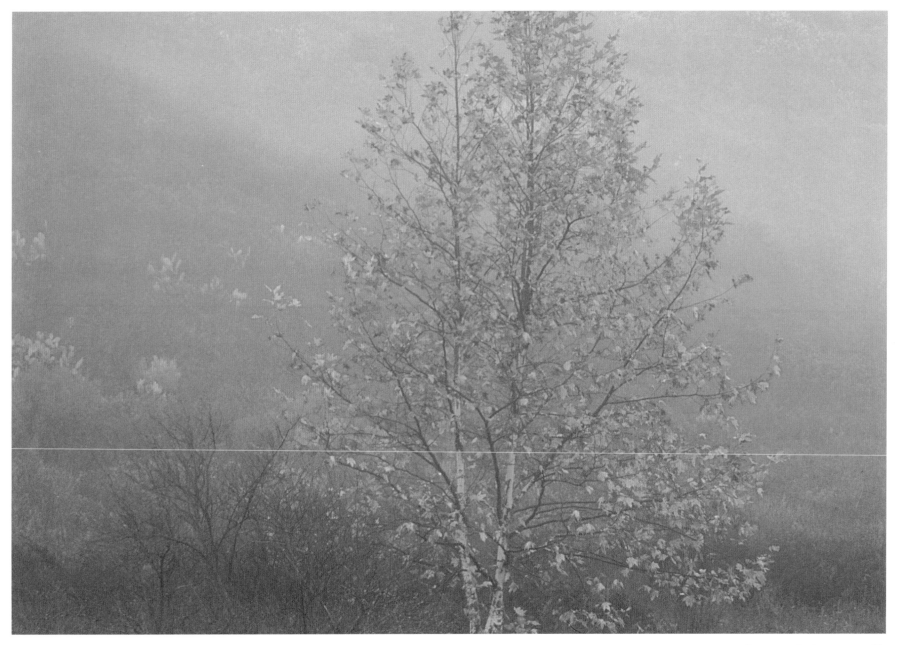

Young Sycamore in Sycamore Hills

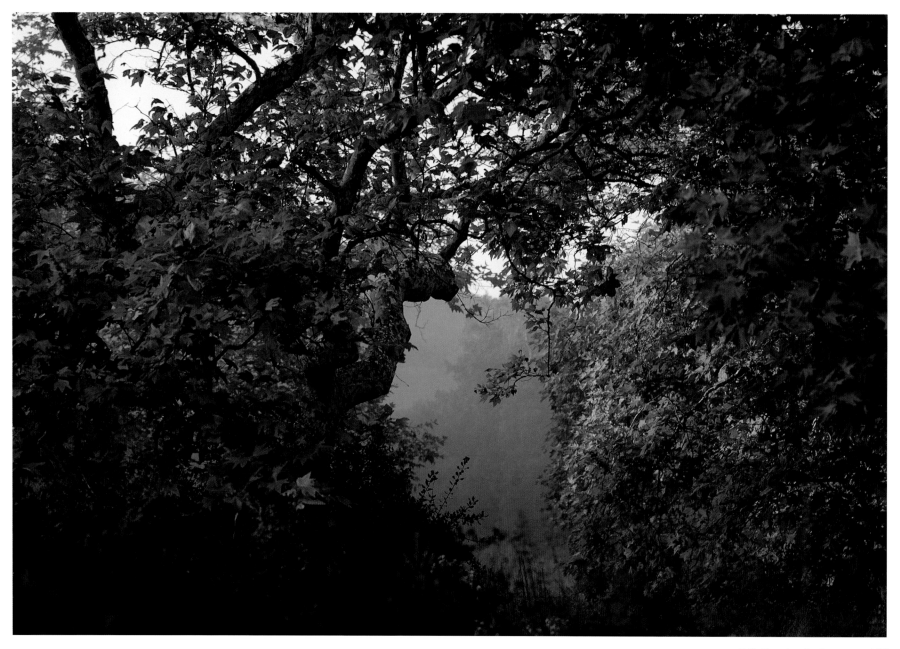

Fall Morning in Sycamore Hills

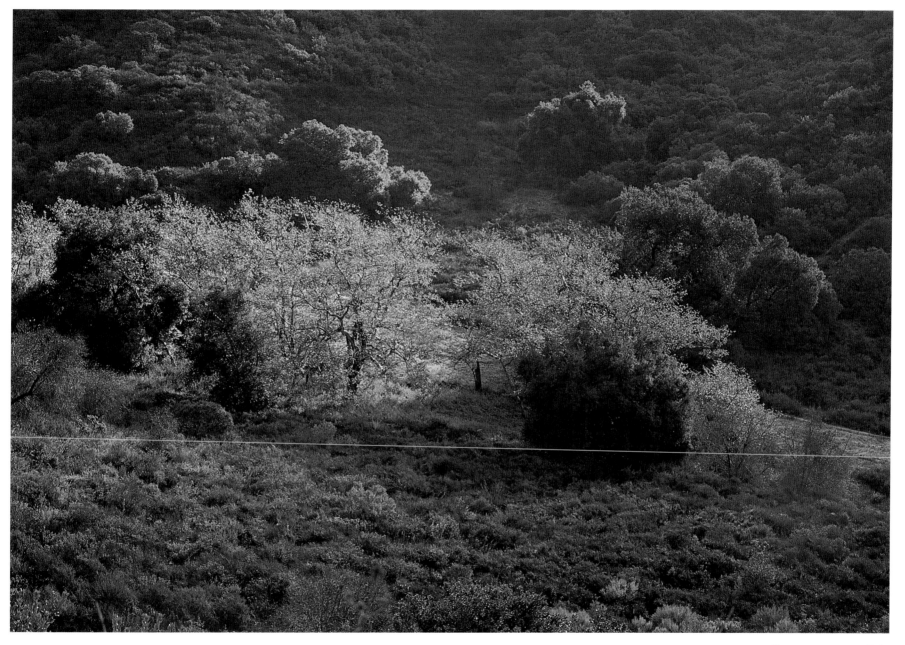

Sycamores among Oaks

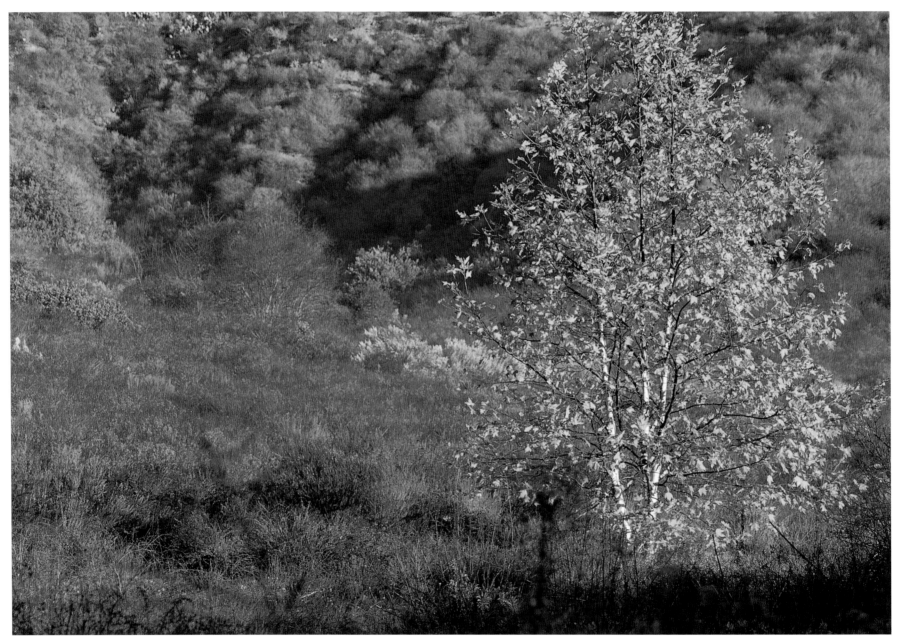

Sycamore in Autumn. Among sage and other native grasses in Sycamore Hills.

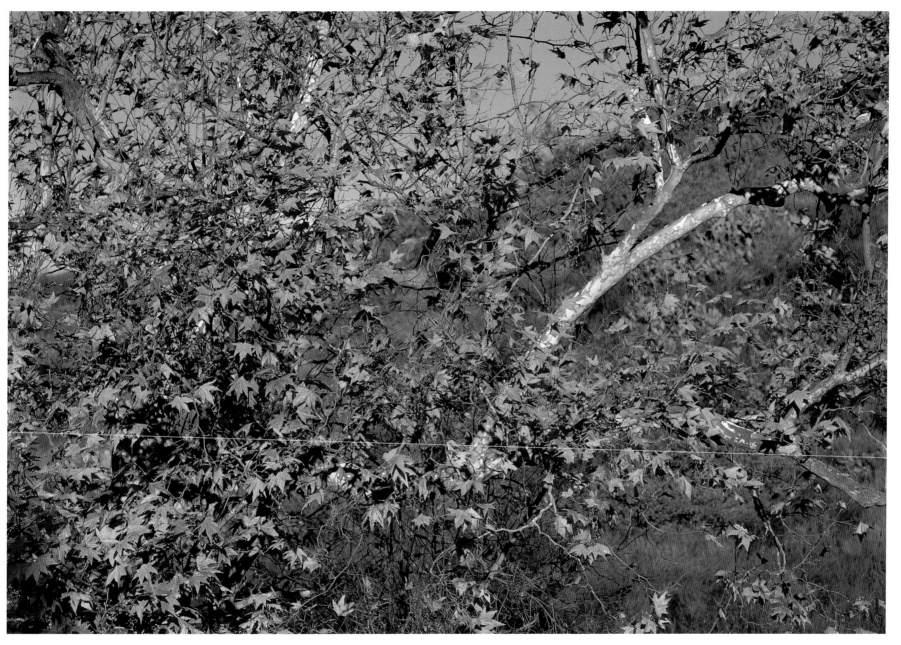

Out of Muddy Canyon

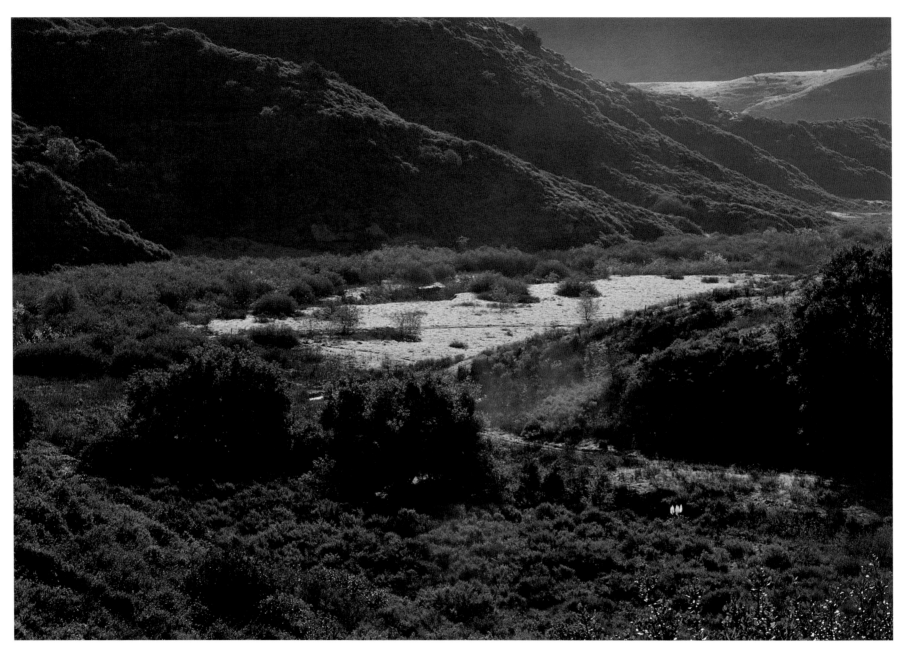

Above Wood and Mathis Canyons

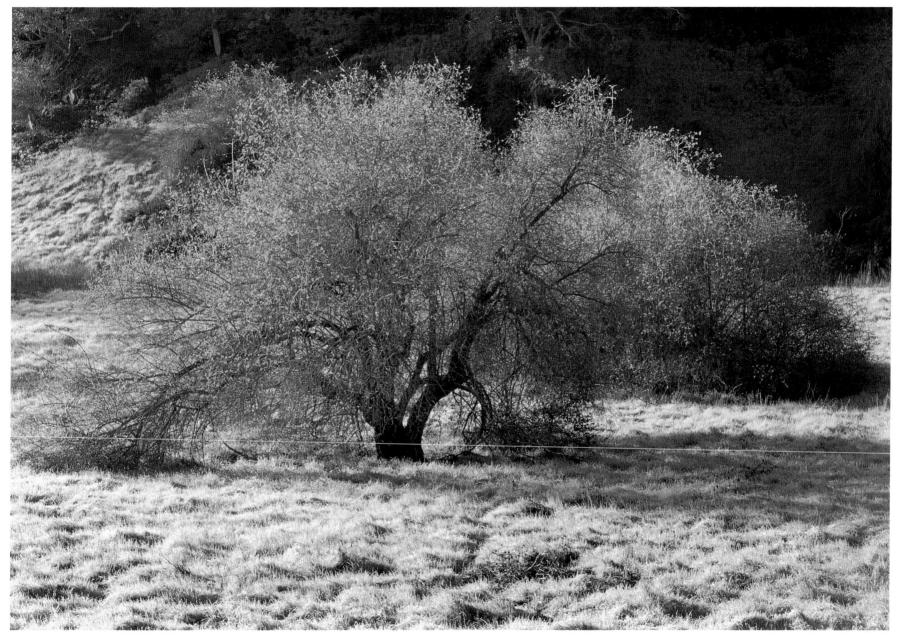

Sycamore in Mathis Canyon

Nature's Laguna Wilderness

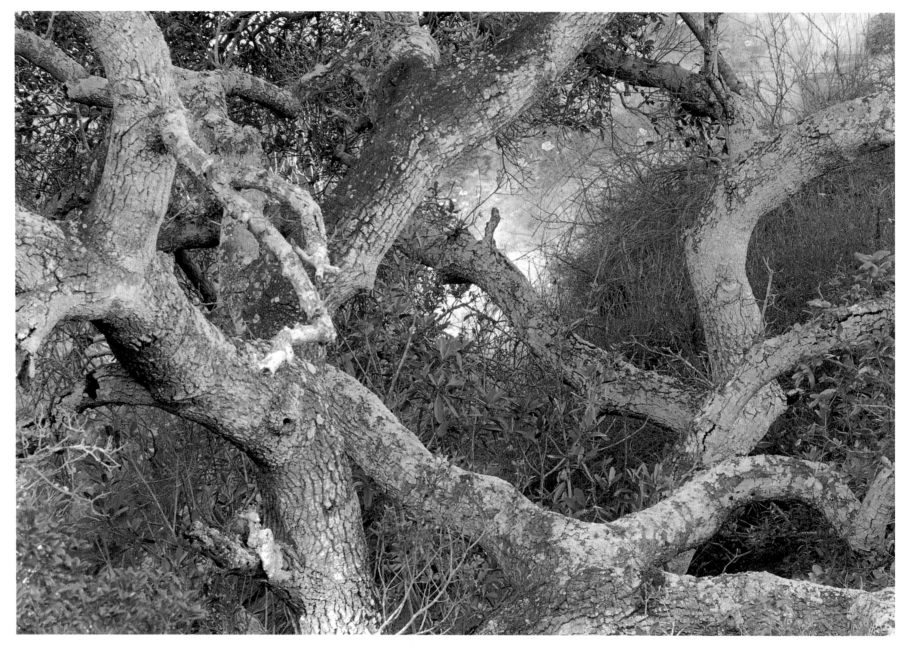

Winter Sycamore in Mathis Canyon

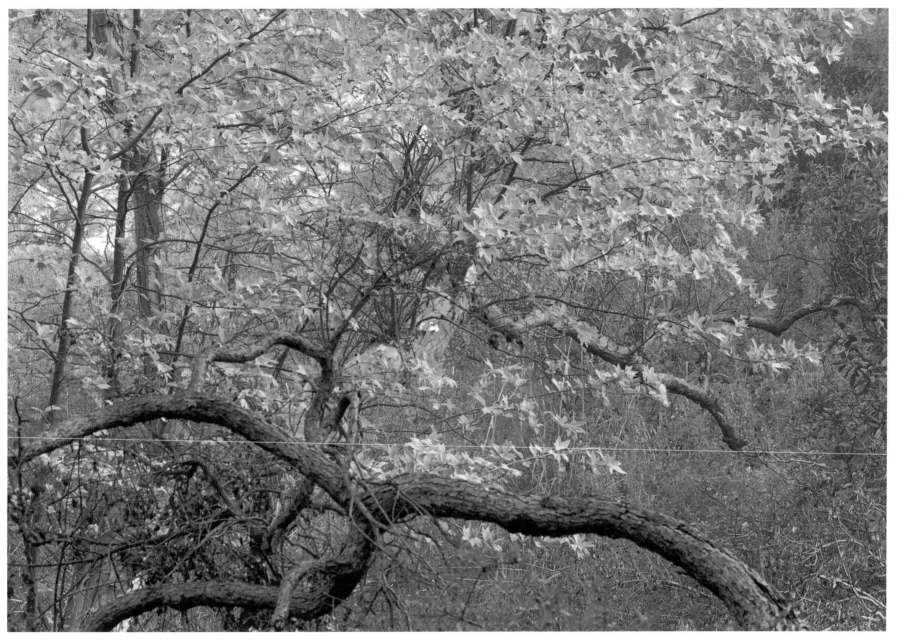

Sycamore in Wood Canyon

The Coastal Canyons

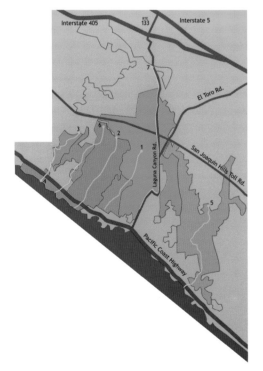

Interstate 405 | RTE 133 | Interstate 5

El Toro Rd.

Laguna Canyon Rd.

San Joaquin Hills Toll Rd.

Pacific Coast Highway

Crystal Cove State Park
Aliso and Wood Canyons Wilderness Park
Irvine Company Open Space
Laguna Coast Wilderness Park

1. Emerald Canyon
2. El Moro Canyon
3. Los Trancos Canyon
4. Crystal Cove
5. Aliso Canyon
6. Muddy Canyon
7. Laguna Canyon

To the north of Laguna Beach, extending to Corona del Mar, are the coastal canyons and waterways reaching to the beaches and ocean below. Hikers and bicyclists long have had access to some of these areas through the Crystal Cove State Park, but there is much to explore and very few of us have touched all its canyons and highlands.

Perhaps the jewel of the coastal canyons is Emerald Canyon reached from Bommer Ridge above. This canyon drops into beautiful oak and sycamore groves with a creek running through during the rainy season and a large waterfall below. From Emerald Canyon it is possible to traverse Old Emerald trail to reach Bommer Ridge and Boat Canyon.

A couple of years ago I set off with my sons, Stephen and Edward, on a walk to Emerald Canyon. At the bottom of the canyon a trickle of water accumulated by the morning drizzle flowed over the falls. What a beautiful spot! In comparison, only the falls in Laurel Canyon is higher and more dramatic when active. Along the path through the oaks and

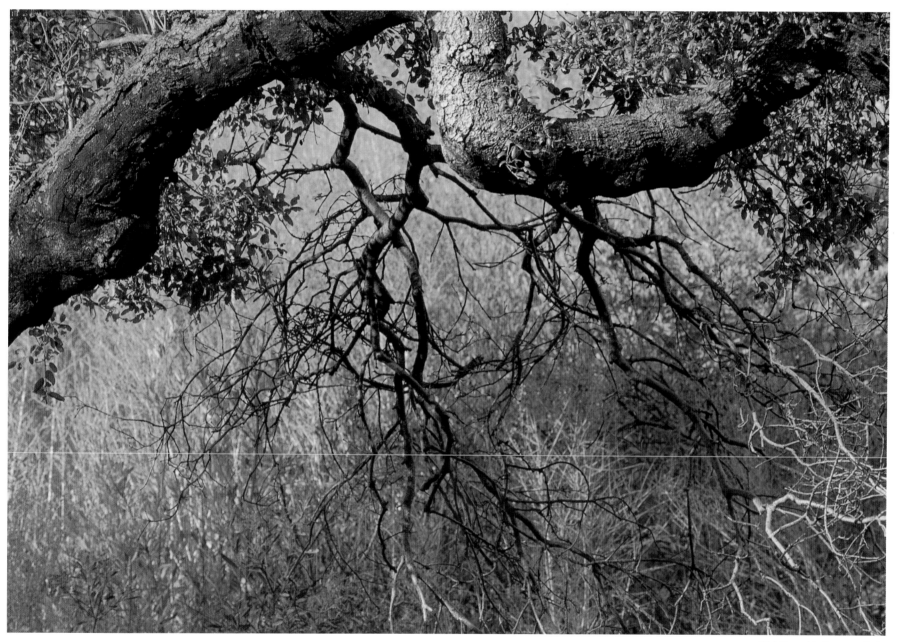

Old Growth Canyon Oak

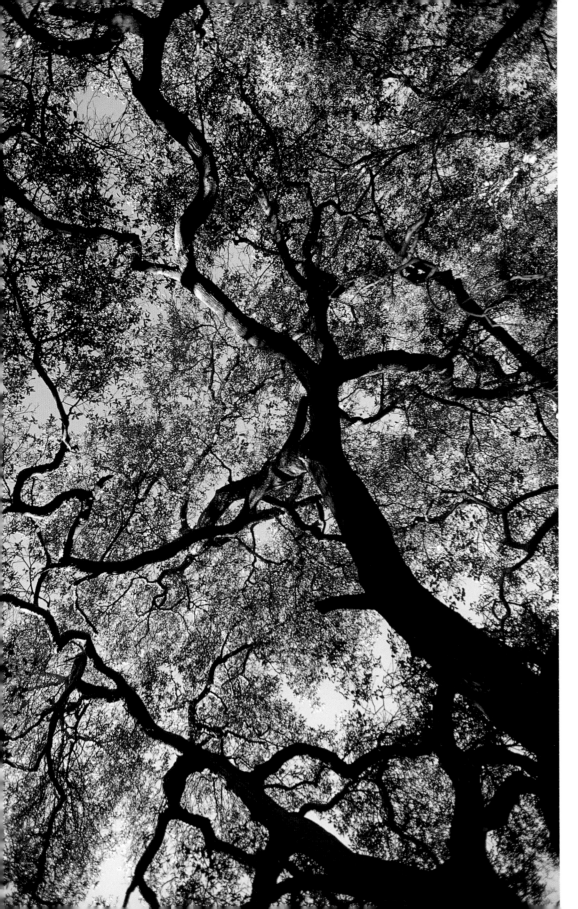

Rising from Emerald Canyon

the sycamores that survived the great fire of 1993, the sun appeared through a cloudy coastal overcast as I photographed the toyan bushes and the burned remnants of bushes on the hillsides. We went up the trail to the north for a brief stretch, then returned to the main trail and up to Emerald Ridge and on to the top, and from there down Laurel Canyon to complete our end of a millennium walk (Personal notes, December 21, 1999).

Near and above the El Morro School there is an entrance to the upper portion of Crystal Cove State Park, specifically up into El Moro Canyon with a diversion to the south being the Moro Ridge Spur and above the East Cut Across to the Moro Ridge. To the north by means of the West Cut one reaches Deer Canyons and Red Tail and No Name Ridges above. The Wishbone trail to the north leads to the Los Trancos area.

A couple of years ago in my search for fall color I walked up El Moro Canyon to No Name Ridge and over toward Los Trancos to observe the extensive movement of dirt and preparation for the housing development below. I

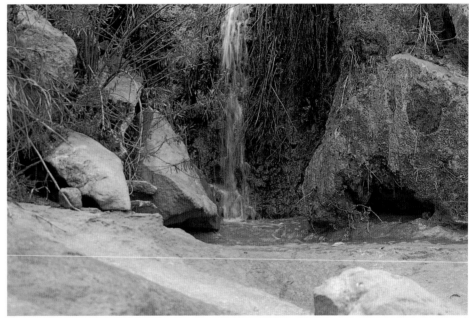

Emerald Canyon Falls After a Rainfall

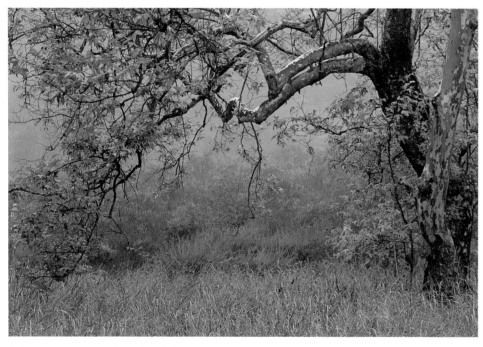

Autumn Mist in Emerald Canyon

walked down from No Name Ridge to the canyon below through which runs a small creek. There were mostly toyan shrubs and bushes along the stark wash where no oak trees stood, and therefore fall color was not possible. I continued walking in the canyon to the north of the state park and came upon a single sycamore with leaves in color. This was very rugged terrain as I hiked a mile through brush until reaching a road with high power lines. Below Signal Peak, where a cluster of communication antennas and transmitters are found, one can descend along the trail to Los Trancos Canyon and into the contiguous housing tracts The Irvine Company has built off Newport Coast Drive

Concerned citizens have long opposed the continuing developments at Crystal Cove and El Morro Beach. Most of the beach area along the ocean side of the coast highway is in a natural state. Only the paved roads, restrooms, and parking areas above intrude upon the pristine area. It was and still is the site of many plein-air paintings and photographs. The cottages at Crystal Cove have deteriorated

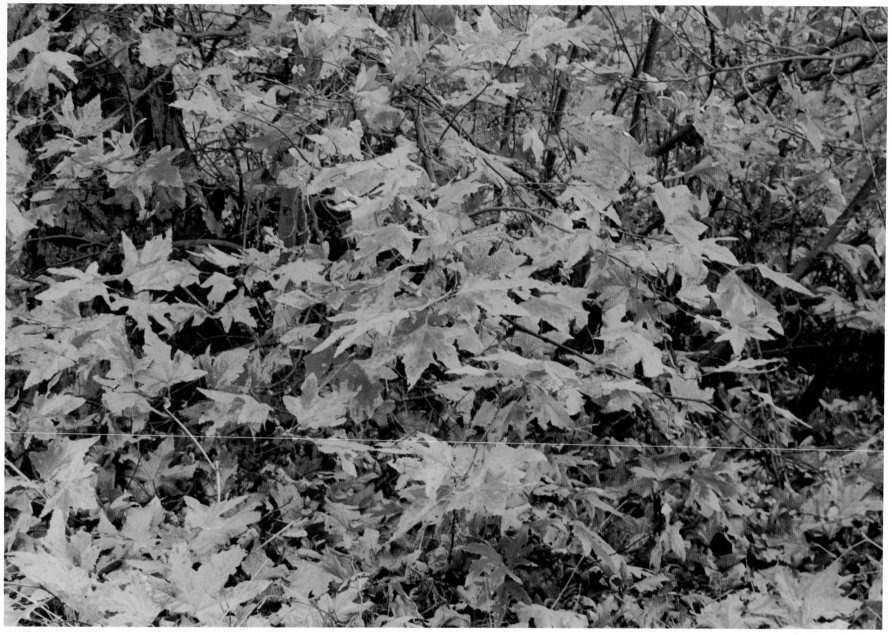

Sycamore Leaves

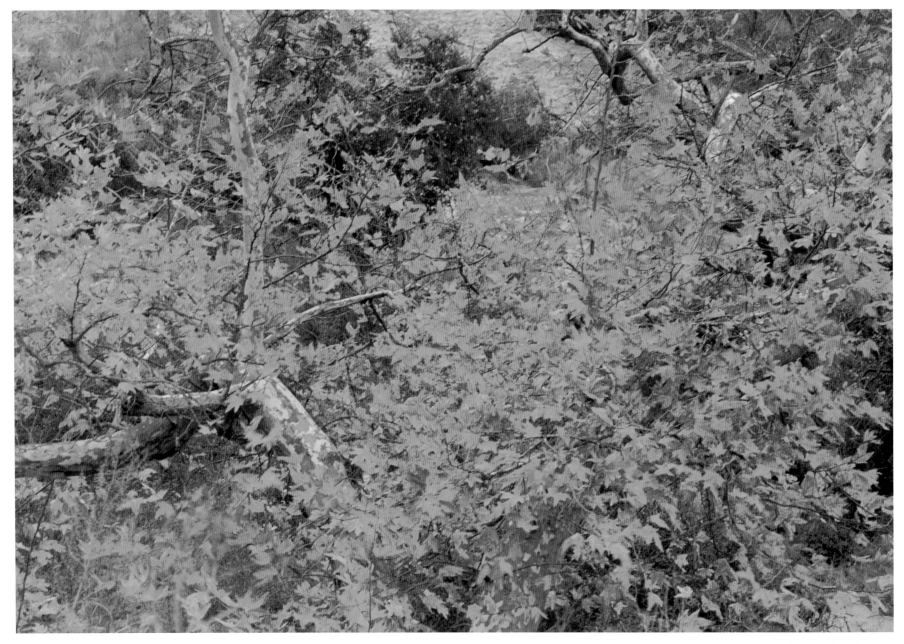

Toward Los Trancos

over the years, some of them quaint and of historical significance, most of them rundown and begging to be torn down so that the landscape can be restored to its natural state. Plans to reshape this historic site into an upscale resort were met with opposition and defeated by environmentalists who reminded us that when the state park was established years ago, it would not dramatically change. It was also assumed that the trailer park at El Morro would eventually be torn down and the area restored to its natural condition, but political pressures kept most of it intact. The plan to develop it for public use would allow for modest campground facilities.

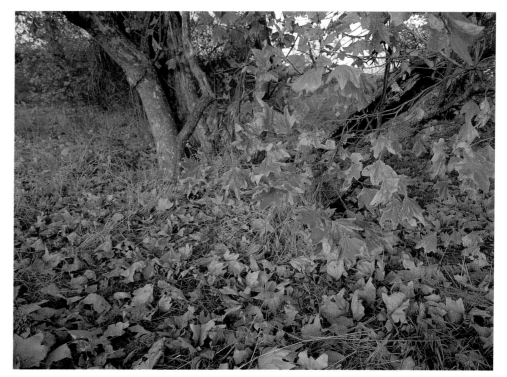

Sycamore in El Moro Canyon

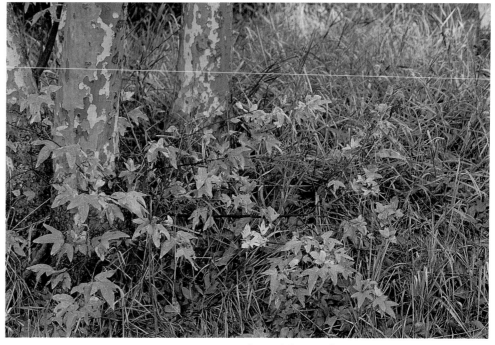

Coastal Canyon Sycamores in Emerald Canyon

The Wetlands

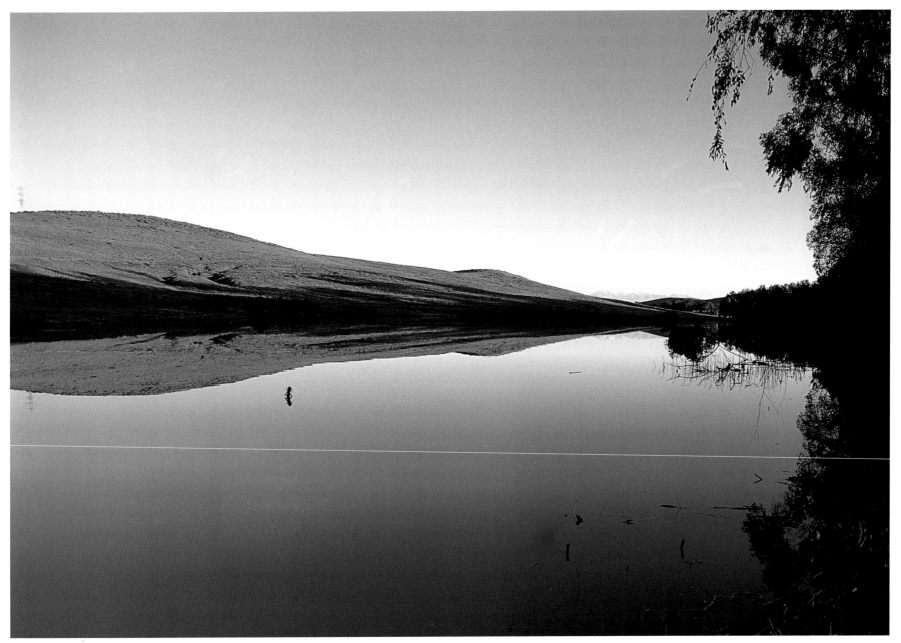

Solitude on Laguna Lake One

The Laguna Lakes are adjacent and accessible from the Laguna Canyon Road but until recently were relatively unknown and hidden from passing motorists by trees and schrubs (McKinney, 2001). The largest, once identified as Lake Three and now named Barbara's Lake (for Barbara Stuart Rabinowitsh who served the Laguna Greenbelt as a longtime activist and benefactor to the Laguna Canyon Foundation) is on the southeast side of the road and backs up to homes in Laguna Woods and is reachable from a trail in Sycamore Hills. Its fingers are covered by bulrush, cattails, and willows and provide habitat for grebes and mallards as well as an occasional egret and heron. Recent restoration has opened its vista to the cars passing by, and the plan to divert the road to the north will allow its natural linkage to what we have called Lake Two which is on the opposite side of the road and was once affectionately called Bubbles Lake in honor of a pregnant hippopotamus who in 1978 escaped from a nearby and now defunct wildlife park and sought refuge by staying under water by day and emerging at night. Bubbles aroused the attention of the world as attempts to capture her eventually

Laurel Creek Reflections

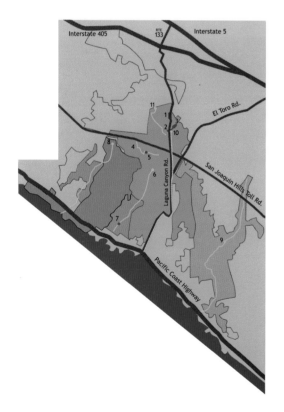

Crystal Cove State Park

Aliso and Wood Canyons Wilderness Park

Irvine Company Open Space

Laguna Coast Wilderness Park

1. Lake 1
2. Lake 2
3. Barbara's Lake
4. Laurel Canyon Creek
5. Laurel Canyon Falls
6. Emerald Canyon Creek
7. Emerald Canyon Falls
8. Muddy Creek
9. Aliso Creek
10. Laguna Canyon Creek
11. Little Sycamore Creek

* The realignment of Laguna Canyon Road would reunite Lake 2 with Barbra's Lake (Lake 3)

failed. After being put to sleep by a tranquilizer dart, she fell against the hillside, causing her fetus to press against her lungs and suffocate her. Close by and to the east along the canyon road and easily visible is Lake One, a vernal lake that has suffered from removal many years ago of oak trees and the planting of water-loving eucalyptus along its edge. At times of heavy rains the lakes have flooded and closed the road to traffic. Many of my photographs are of these lakes.

The streams of the canyons also flow after heavy winter rain, and the streambeds tend to run for several months in the late winter and early spring. Aliso, Emerald, Laurel Canyon, and Little Sycamore Creeks are the most interesting. Laurel Creek, for example, runs alongside the trail through Laurel Canyon, carving its way through three significant groves of California oak and sycamore trees with creek crossings at a couple of points along the way and a waterfall near the top of the trail. During heavy rainfall, as was the case in l998, water both runs off and is absorbed in the adobe soils until it begins to surge forth, filling the creek and running heavily so that at special moments it gushes over the precipice and digs its way below.

Patterns and Reflections.
On Laguna Lake Two.

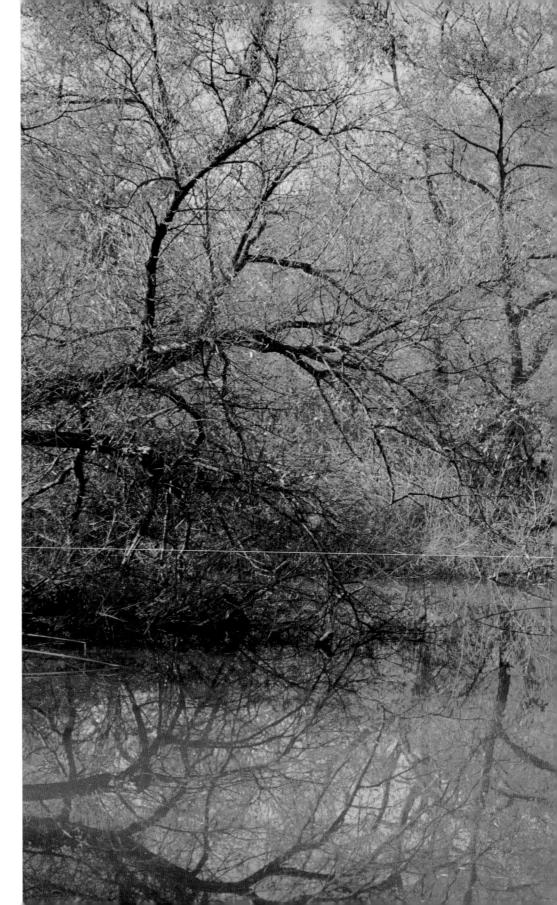

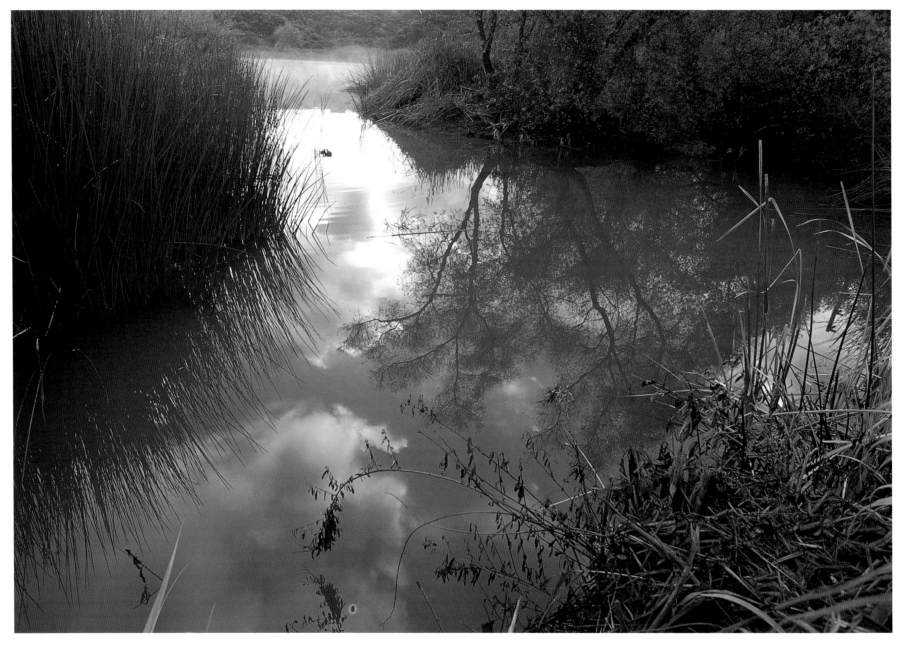

Morning Reflection on Barbara's Lake

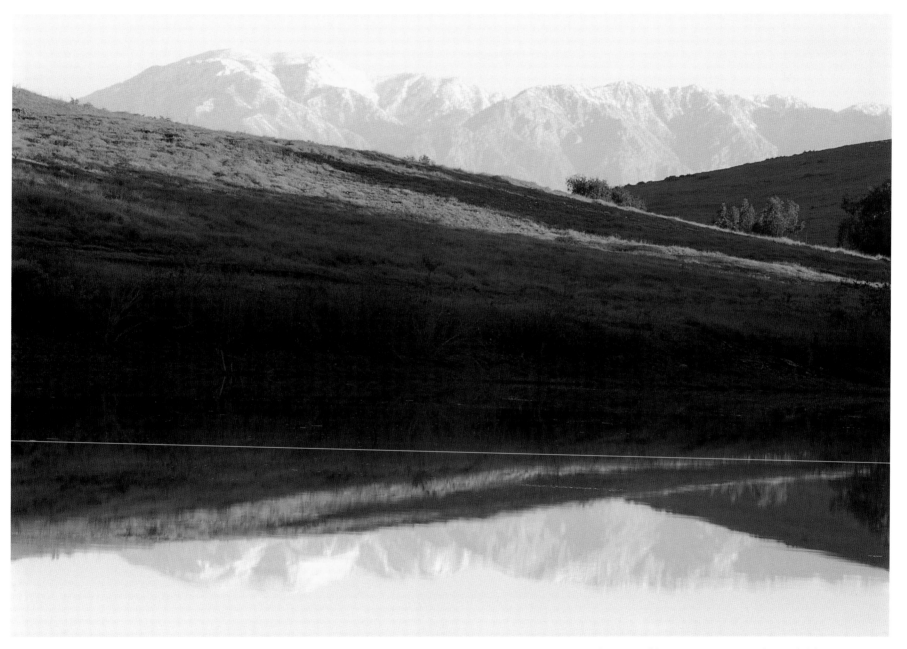

Laguna Lake One and Mt Baldy in Snow. On a clear day after a rainstorm showing seldom-seen mountains located fifty miles away.

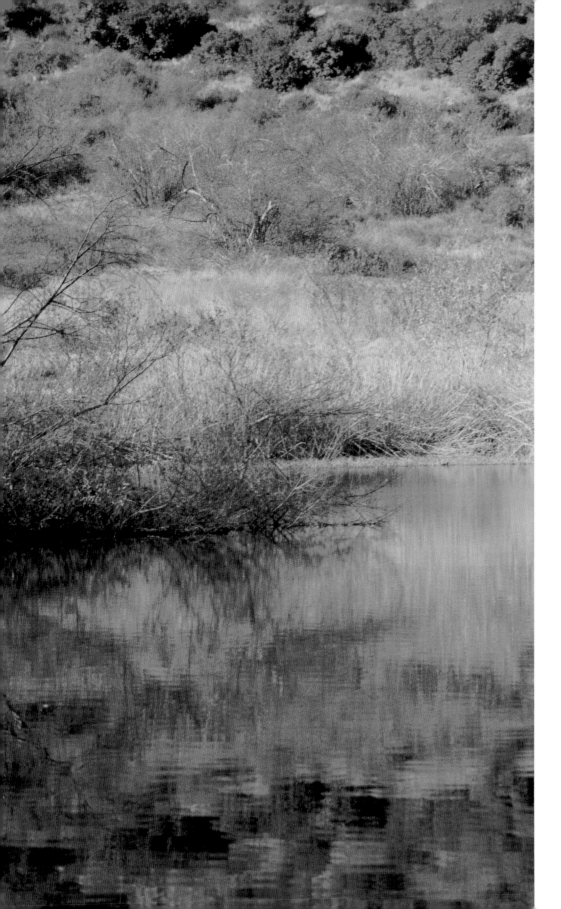

Landscape Impression.
On Laguna Lake Two.

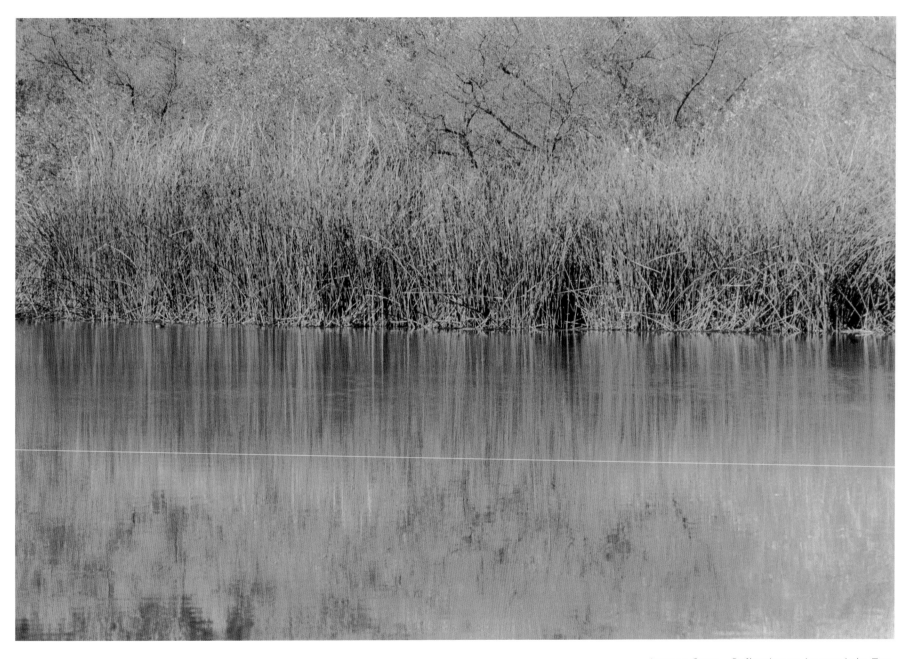

Autumn Grass. Reflection on Laguna Lake Two.

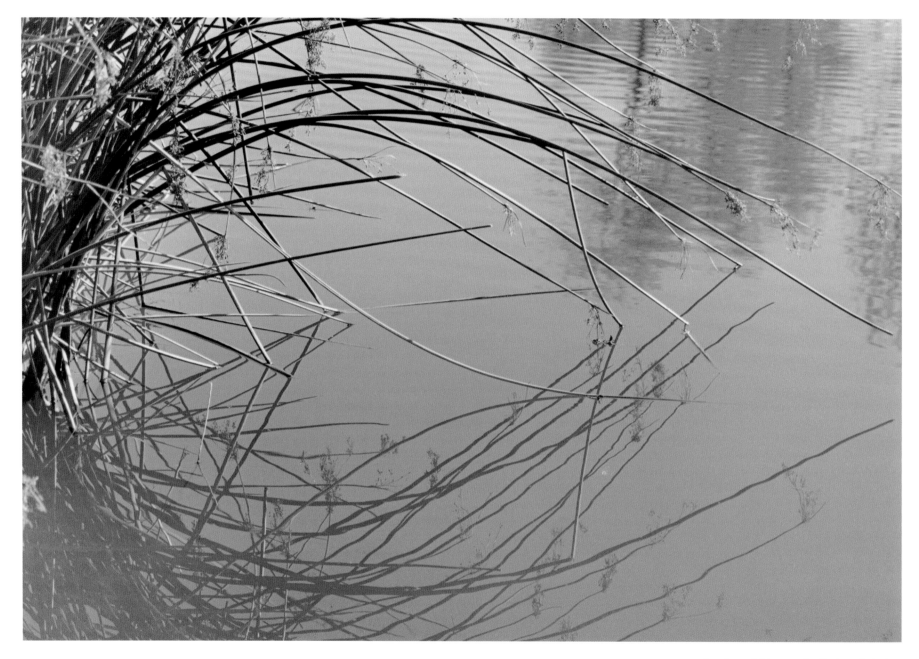

Reeds and Water. On Barbara's Lake.

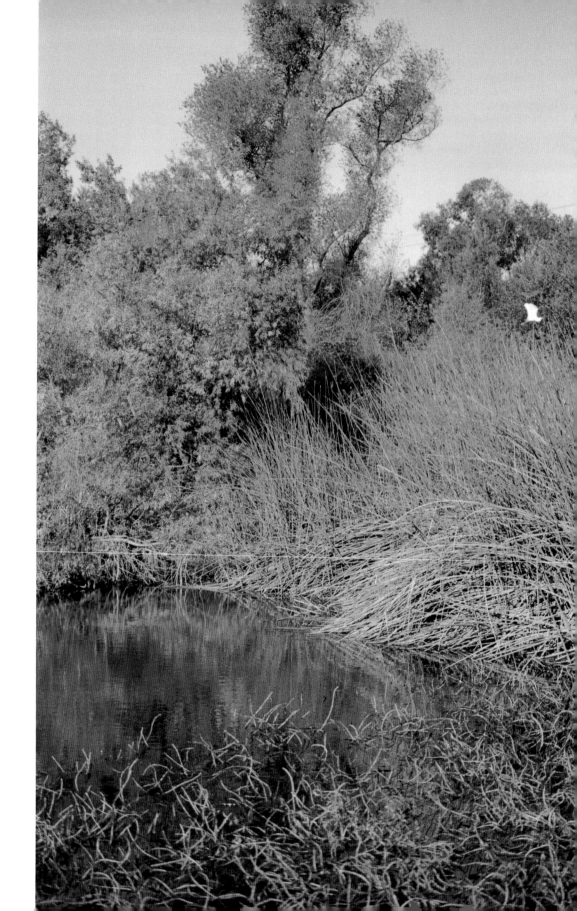

Autumn Color with Egret.
On Laguna Lake Two.

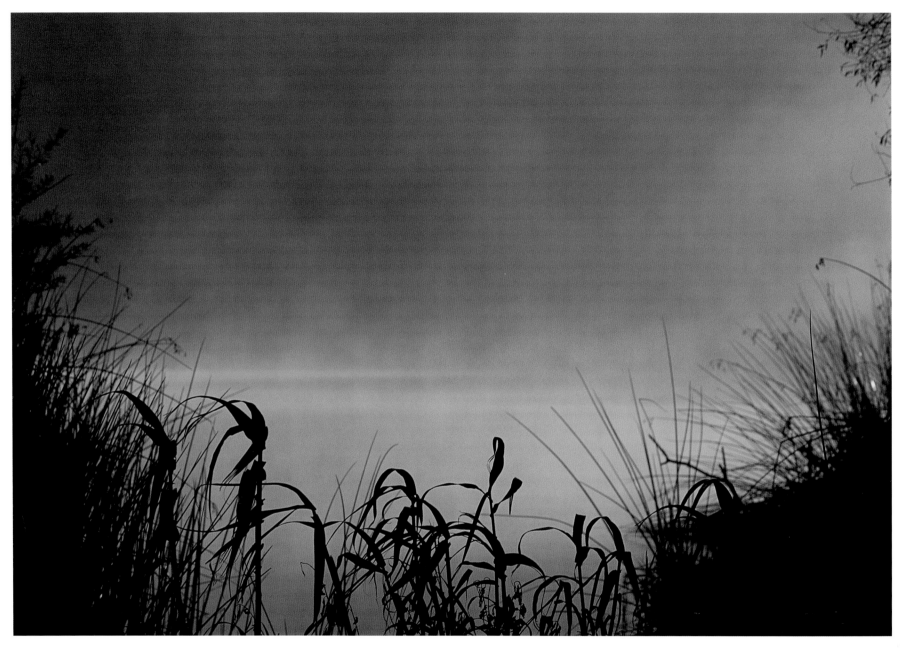

Mist and Grasses. Fog on Barbara's Lake as the sun pushes through the early morning fog.

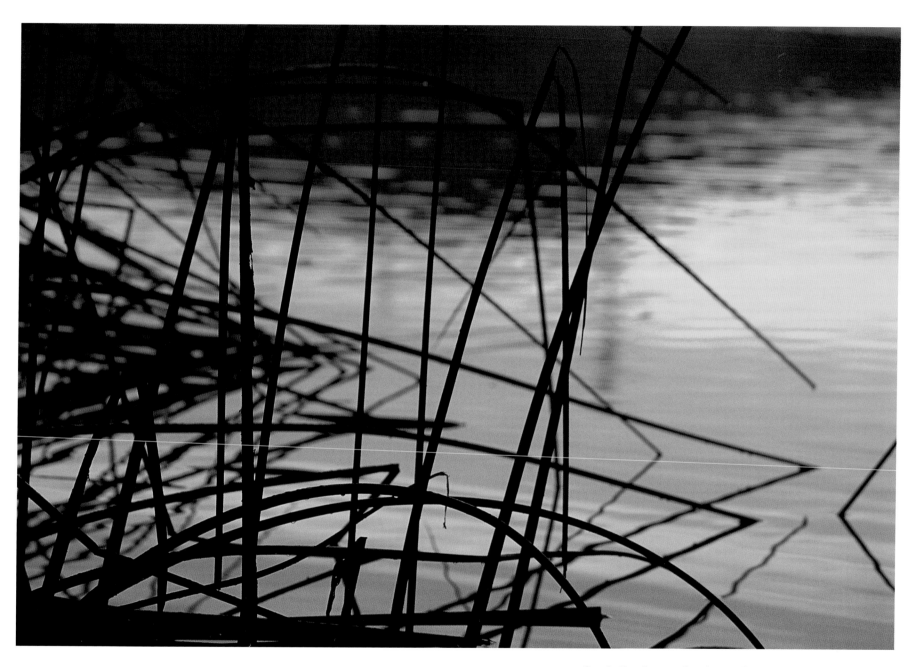

Sun Reflections on Reeds. Early morning at Barbara's Lake.

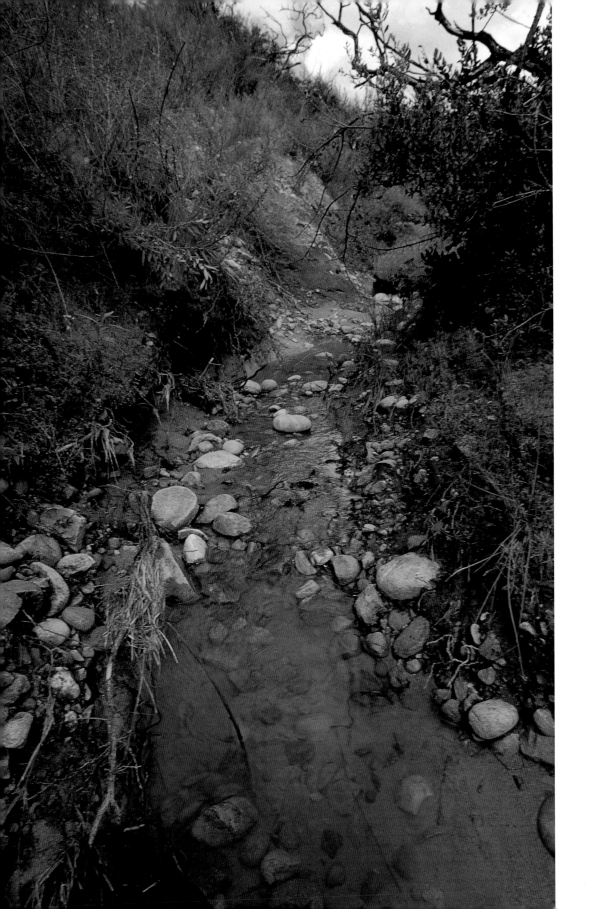

Little Sycamore Canyon Creek.
After a storm.

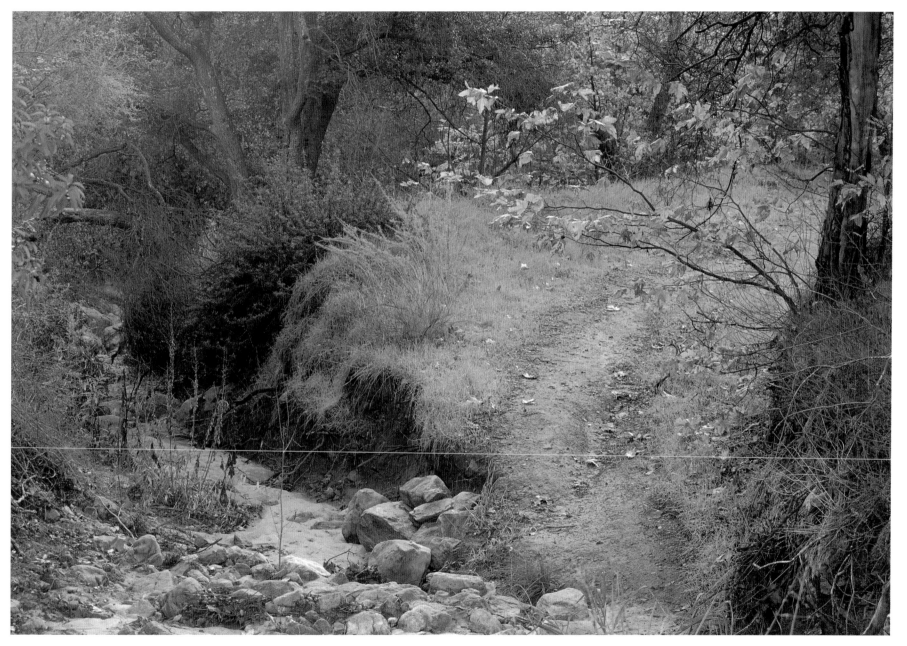

Laurel Canyon Creek. Late autumn flow.

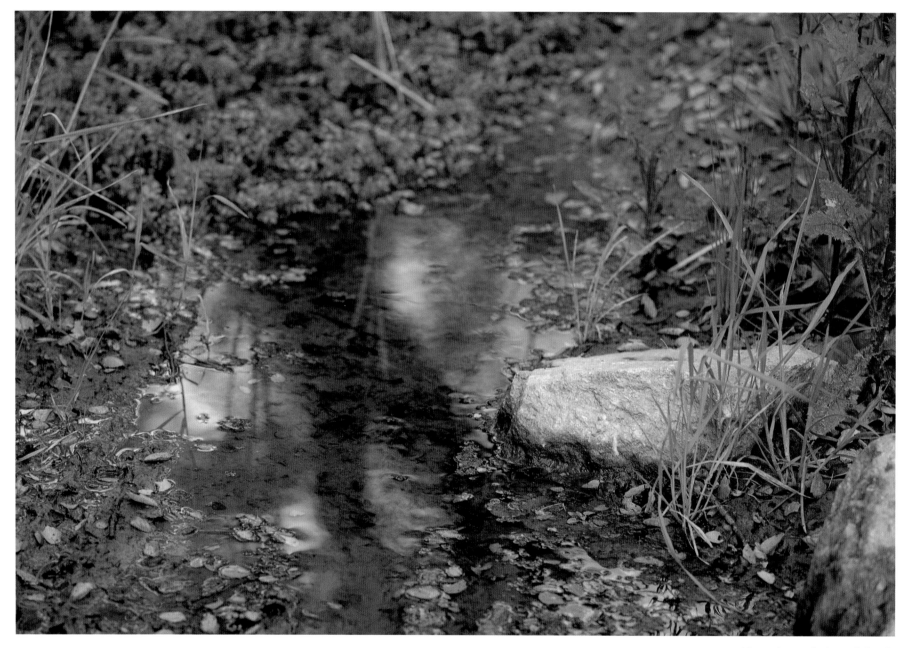

Water Image in Laurel Creek

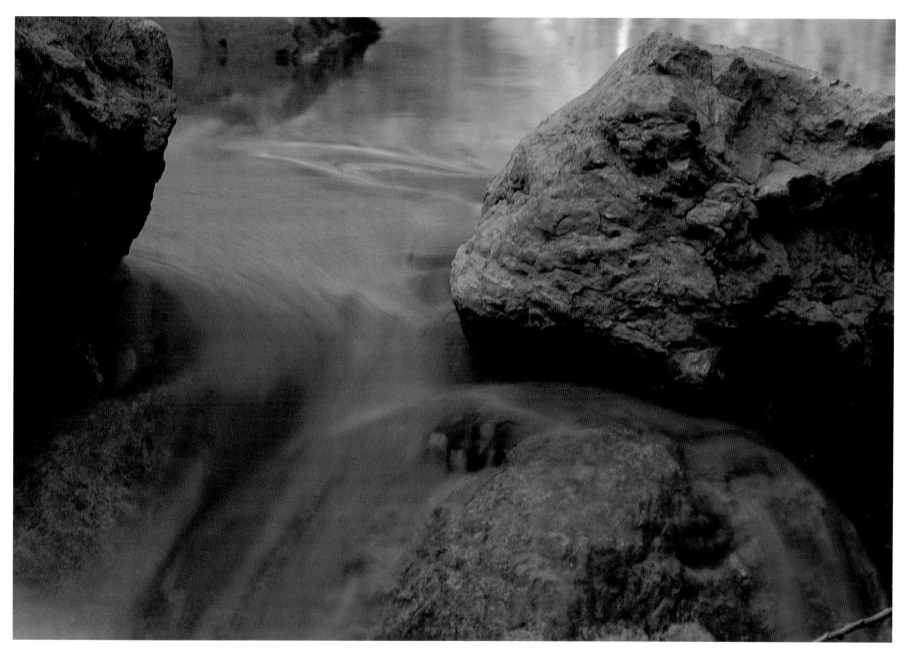

Gold and Green Water Falling. An unusual image in Laurel Creek.

The Coastal Waters

Between Laguna Beach and Corona del Mar stretches Crystal Cove State Park. It extends three miles along the coast of sandy beaches and cliffs and reaches inland to the watershed of Los Trancos Canyon with its natural ravines and ridges, but its runoff is threatened by pollution from North Coast developments and a golf course. I do not include photos of the beachfront cottage community that has been listed by the National Register of Historical Places, but I have photographed this area and its beaches, tide pools, and bluff tops which are brown and drab in summer and autumn and lush green during the rainy winter and early spring. The images that follow reveal how dramatic nature becomes in the setting sun over Catalina Island and the ocean waters as they flow over tide pools and on to the beach.

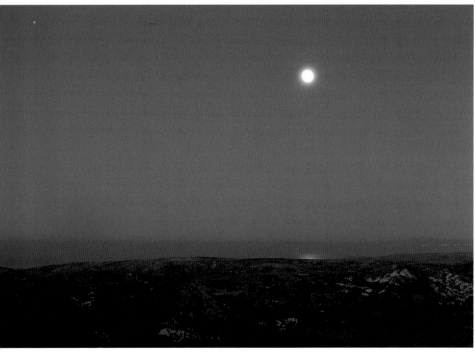

The Christmas Moon in Early Morning Over the Coastal Canyons. A rare occurrence, this full moon appeared on December 25, 1996.

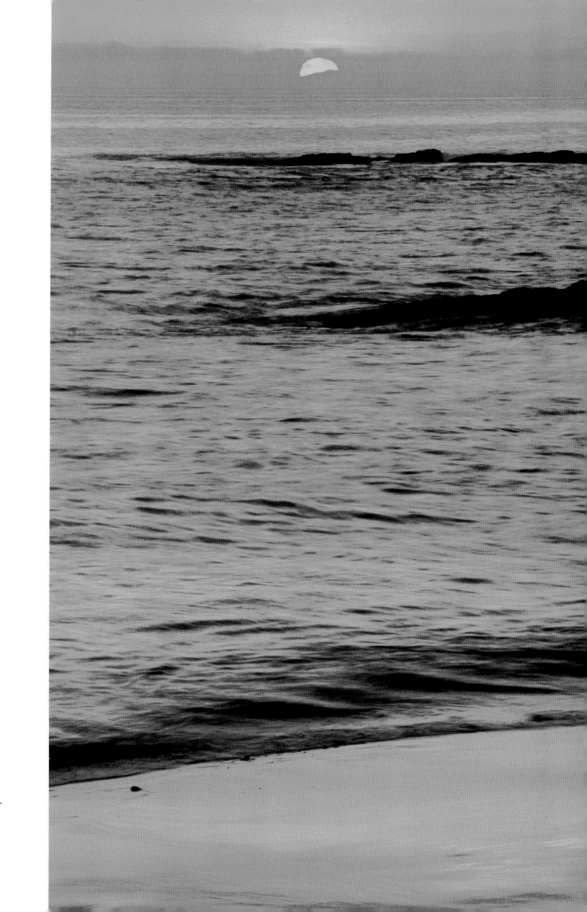

Sunset over Crystal Cove.

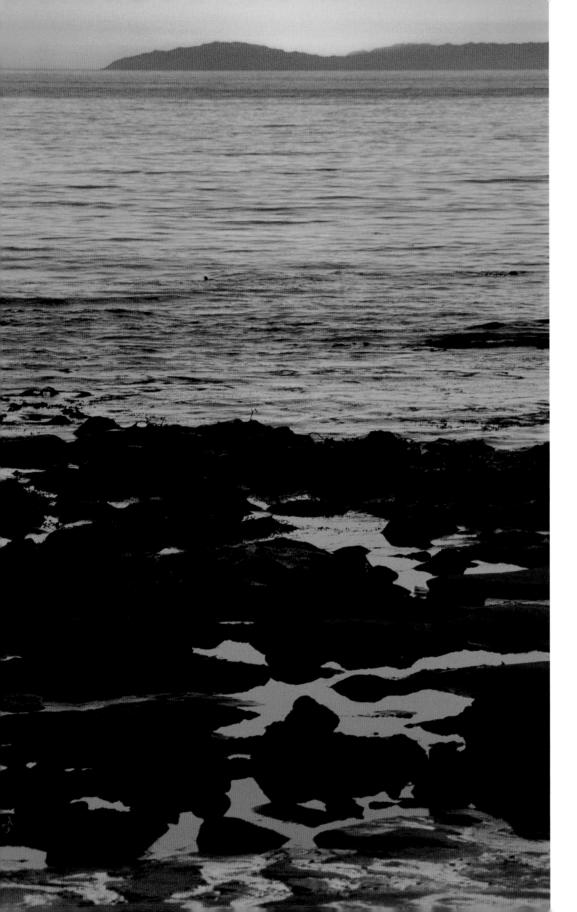

Muddy Creek runs through its canyon above and reaches the ocean just north of the El Morro School and the park staging area, while to the south a stream moves through El Moro Canyon to the present trailer park along the beach. Emerald Creek runs through its canyon and over a waterfall just above Emerald Bay and a closed community of homes situated along the beach. Except during the rainy season we do not see much water flowing through Boat Canyon, Laguna Canyon, and other tributaries that have been obscured by development. Further to the south Wood and Aliso Canyons join as Aliso Creek flows to the beach below, but it too has been beset by pollution from the housing tracts in Aliso Viejo so that the ocean beaches are often closed to swimming.

Tidepools and Catalina.

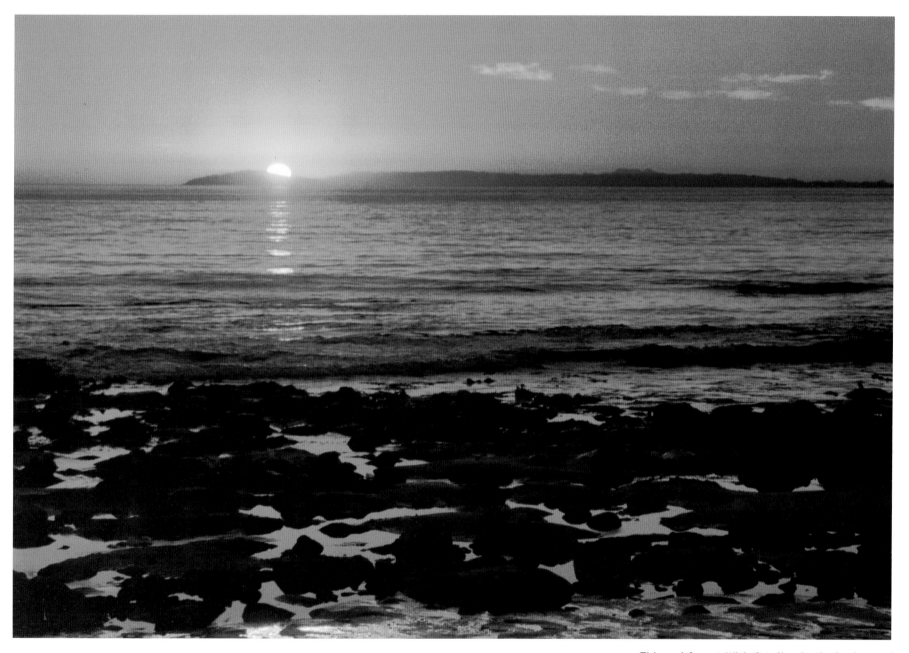

Tidepool Sunset. With Catalina in the background.

Flora and Fauna

Diverse flora are prominent in the low-
lands. California sagebrush is soft, thin, with
light green leaves and sage odor. The coastal
sage-scrub consists of small bushes of black
and white sage. The California wild buckwheat
has clumps of white or pink flowers that turn
red after pollination. Larger shrubs include
laurel sumac and lemonade berry. At higher
elevations is the chaparral, including scrub
oak and toyan. In the canyons the southern
oak woodland includes the live oak and the
sycamores. Where there was once heavy graz-
ing, one now finds non-native grasses and mus-
tard. Riparian woodland communities of live
oaks, sycamores, and cottonwoods are found
alongside streams and creeks, empty of water
throughout most of the year. During the late
winter and early spring the native wildflowers
bloom, and the canyons are alive with color. In
the early spring the coastal sage-scrub vegeta-
tion is interspersed with colorful sticky mon-
keyflower, goldenbush, and the yellow bush
sunflower. There are also prickly pear cactus

Egret and Reflection in Laguna Lake

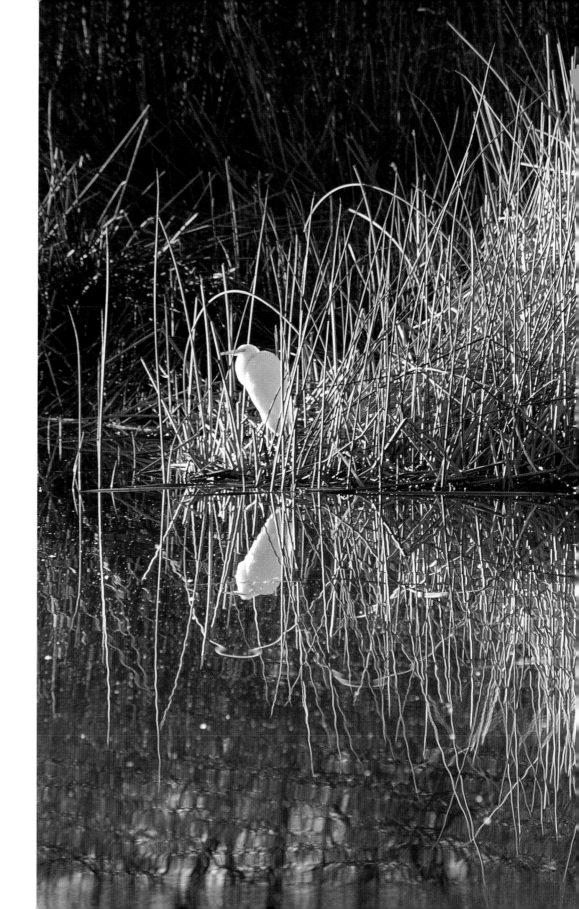

and cholla cactus. Nadine Nordstrom has prepared a plant identification guide of these and other species in a small brochure available from the Laguna Canyon Foundation.

Fauna include an occasional mountain lion, bobcats, mule deer, coyote, along with

Dew on Leaves

raccoons, rabbits, skunks, opossums, squirrels, woodrats, and mice. Snakes include the yellow- and brown-patterned gopher snake, the common garden snake with a bright orange ring behind the head, the black and yellow-white banded king snake, and the rattlesnake with its triangular shaped head. Occasional birds visiting the Laguna Lakes include the snowy egret and the blue heron, and one frequently encounters the red tail hawk and the raven. Three endangered species are the coastal California gnatcatcher, the coastal cactus wren, and the orange-throated whiptail lizard. Along the coast between Laguna Beach and Corona del Mar, some 180 species of birds have been found according to the field checklist of the Crystal Cove Interpretative Association.

With the ocean to the west and the mountains to the east, the Laguna Wilderness is part of an "insular" biological region in which more than a hundred native plants and animals "have nowhere to go if the coastal sage scrub were to disappear" (Brown, 2002: 4). The threat to their survival is real because these species are threatened by millions of people in urbanized settings that destroy unique habitats and by alien plants and animals introduced over the past century, such as pampas grass, giant reed, artichoke thistle, mustard, and tree tobacco and alien wildlife such as African bullfrogs and mosquita fish in the lakes, and starlings and English sparrows in the hillsides and canyons.

Monkey Flowers

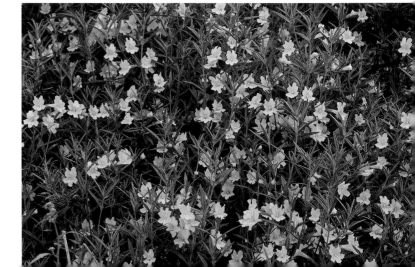

References

Armor, Samuel. 1921. *History of Orange County*, California. Los Angles: Historic Record Company.

Bauer, Helen, 1953. *California Rancho Days*. Garden City, New York: Doubleday and Company.

Blacketer, Belinda. 2001."History of Laguna Canyon." Manuscript, Laguna Beach.

Brown, Elisabeth. 2002. "Hotspots are Hotbed of Homogenization," *Laguna News-Post* (May 9):4.

Chamberlain, Mark. 1988. "The Laguna Canyon Project: Documenting Countrycide," *Journal of Orange County Studies*, 1 (Fall), 9-18.

Cleland, Robert Glass. 1952. *The Irvine Ranch*. San Marino: Huntington Library.

Cramer, Marie H. et al. 1986. *The Golden Promise. An Illustrated History of Orange County*. Northridge, California: Windsor Publications.

Estes, Leland L. and Robert A. Slayton eds. 1990. *Proceedings of the Conference of Orange County History*. 1988 and 1989. Orange: Chapman College. Brief essays by Sharen Heath and Ed Hobert, pp 233-241 in the 1988 volume and by Nicholas M. Magalousis and Ruth Zimmerman, pp. 41-44 and by Joan Pizzo, pp. 141-144 in the 1989 volume.

The Irvine Company. 2002. *The Irvine Ranch Land Reserve*. Irvine,

Irvine Ranch. [2001]. *Different by Design: Images 1960-2000*. Newport Beach: The Irvine Company.

Jones, Roger W. 1997. *California: from the Conquistadores to the Legends of Laguna*. Laguna Beach: Rockledge Enterprises.

Lee, Seung Huen. 2000. *Healing Society. A Prescription for Global Enlightenment*. Charlottsville: Hampton Roads Publishing.

Loeb, Paul Rogat. 1999 *Soul of a Citizen. Living with Conviction in a Cynical Time*. New York: St Martin's Griffin.

Luna-Seeden, Kathlene. 1985. "A Look Back at Laguna," *Orange County Register* (October 1), 3-4

Maxsenti, Michael A. 1998. *Laguna Beach. Local Color*. Newport Beach: The Max Company.

Meadows, Don. 1966. *Orange County Under Spain, Mexico, and the United States*. Los Angeles: Dawson's Book Shop.

McGirr, Lisa. 2001. *Suburban Warriers. The Origins of the New American Right*. Princeton: Princeton University Press.

McKinney, John. 2001. "In Orange County, Exploring Laguna Canyon's Natural Lakes," *Los Angeles Times* (November 18) L4.

Miller, Hortense. 2002. *A Garden in Laguna*. Dana Point: Casa Dana Books.

Morris-Smith, Briggs Christian. 1979. "The Excavation and On-Site Living Experience of ORA-379." Fullerton: MA Thesis, California State University, Fullerton.

Moure, Nancy Dustin Wall. 1998. *California Art: 450 Years of Painting and Other Media*. Los Angeles: Dustin Publications.

Obata, Chiura. 1993. *Obata's Yosemite. The Art and Letters of Chiura Obata from his Trip to the High Sierra in 1927*. Yosemite National Park: Yosemite Association.

Olin, Spencer C. 1991A. "Globalization and the Politics of Locality: Orange County, California, in the Cold War Era," *Western Historical Quarterly* 22 (May): 143-161.

Olin, Spencer C. 1991B. "Intraclass Conflict and the Politics of a Fragmented Region," In Rob Kling, Spencer Olin, and Mark Poster (eds), *Postsuburban California: The Transformation of Orange County since World War II*, Berkeley: University of California Press.

Ramsey, Merle and Mabel. 1976. *The First 100 Years in Laguna Beach, 1876-1976*, Laguna Beach.

Ramsey, Merle and Mabel. 1967. *Pioneer Days of Laguna Beach*. Laguna Beach: Hastie Printers.

Rowell, Galen. 2001. *Galen Rowell's Inner Game of Outdoor Photography*. New York: W. W. Norton.

Schad, Jerry. 1996. *Afoot and Afield in Orange County*. Berkeley: Wilderness Press. 2d ed.

Thurston, J.S. 1947. *Early Days in Laguna Beach*. Culver City: Murray & Gee.

Turnbull, Karen Wilson. 1977. *Three Arch Bay*, Santa Ana: Friis Press.

Turnbull, Karen Wilson. 1988. "Laguna Beach and South Laguna," pp.122-126 in Cramer, Esther R. et al eds. 1988. *A Hundred Years of Yesterdays: A Centennial History of the People of Orange County and their Communities*. Santa Ana: Orange County Centennial.

Viebeck, Beryl Wilson. 1995. "Family Life in Early Orange County: Interview by Eileen DeCair." [Santa Ana]: Orange County Pioneer Council and California State University, California Oral History Program. Interview focused on the Henry Rogers family.

Williams, Terry Tempest. 2001. *Red. Passion and Patience in the Desert*. New York: Pantheon Books.

The Laguna Wilderness Press gratefully acknowledges the generous support of the Foundation for Sustainability and Innovation.

Book Design
Mark Caneso
David Caneso

Production Coordinators
Paul Paiement
Jerry Burchfield

Printed in Singapore by Imago

Scans & Separations
Bright Arts (H.K.) LTD.

Library of Congress Control Number:2003091793
ISBN:0-9728544-0-1

Laguna Wilderness Press
P.O. Box 149, Laguna Beach, CA, 92652-01949
909 827-1571
Email orders@lagunawildernesspress.com
www.lagunawildernesspress.com

The Laguna Wilderness Press is a non-profit press dedicated to publishing books concerning the presence, preservation and importance of wilderness environments.

The Author

Ron Chilcote is a landscape and nature photographer whose interests emanate from a tradition of family interest in photography and who has devoted most of his career to teaching and research on the third world. He is the author of 13 scholarly monographs and 15 edited books. He resides in Laguna Beach with his wife, Fran, where he has been active in community affairs, including efforts to preserve the open space in and around Laguna Beach.